INVISIBLE PRESENCE

INVISIBLE PRESENCE

INVISIBLE PRESENCE

A Walk through Indiana in Photographs and Poems

Photographs by Darryl D. Jones | *Poems by* Norbert Krapf

FOREWORD BY SCOTT RUSSELL SANDERS

AN IMPRINT OF
INDIANA UNIVERSITY PRESS
BLOOMINGTON AND INDIANAPOLIS

This book is a publication of

Quarry Books

An imprint of
Indiana University Press
601 North Morton Street
Bloomington, IN 47404-3797 USA

http://iupress.indiana.edu

Telephone orders 800-842-6796
Fax orders 812-855-7931
Orders by e-mail iuporder@indiana.edu

Library of Congress Cataloging-in-Publication Data

Jones, Darryl, 1948–
 Invisible presence : a walk through Indiana in photographs and poems /
photographs by Darryl D. Jones ; poems by Norbert Krapf.
 p. cm.
 Includes index.
 ISBN 0-253-34753-X (alk. paper)
 1. Indiana—Pictorial works. 2. Indiana—Poetry. I. Krapf, Norbert, 1943–
II. Title.
 F527.J68 2006
 917.72022'2 2005024685

1 2 3 4 5 11 10 09 08 07 06

I DEDICATE THIS BOOK TO MY WIFE NANCY,
MY SON AARON, MY DAUGHTER HANNAH, AND
MY 92-YEAR-OLD FATHER WILLIAM B. JONES, JR.

DARRYL D. JONES

I DEDICATE THIS BOOK TO MY WIFE KATHERINE,
OUR CHILDREN ELIZABETH AND DANIEL, AND
OUR INDIANA RELATIVES AND FRIENDS

NORBERT KRAPF

I have met but one or two persons in the course of my life who understood the art of Walking, that is, of taking walks,—who had a genius, so to speak, for *sauntering,* which word is beautifully derived "from idle people who roved about the country, in the Middle Ages, and asked charity, under pretense of going *à la Sainte Terre,*" to the Holy land, till the children exclaimed, "There goes a *Sainte-Terrer,*" a Saunterer, a Holy-Lander. They who never go to the Holy Land in their walks, as they pretend, are indeed mere idlers and vagabonds; but they who do go there are saunterers in the good sense, such as I mean.

HENRY DAVID THOREAU, "WALKING"

CONTENTS

FOREWORD

Scott Russell Sanders

MIDWAY THROUGH an Indiana summer, my wife and I have begun to harvest tomatoes from our backyard garden. One plump red fruit gleams in a bowl on the table next to me as I write, a shape and color familiar to me since childhood. After spending a few hours in the pages of *Invisible Presence,* however, I can see once more beyond the familiar to the miraculous. I can see this tomato is not merely a flavorful ball of juice contained within a taut skin. It is a globe compounded of sunshine, rain, dirt, bee visits, and wind. There would be no tomato without the sun, no sun without previous generations of stars, no stars without the original burst of energy that set the universe in motion, no shapely universe without a web of rules governing the evolution of things. The entire cosmos and fourteen billion years of preparation went into the making of this tomato, as they have gone into the making of you and me and everything we behold.

This vision of the universe as a shimmering, seamless whole has emerged from science only in recent decades, but it has been known to mystics for ages. A century and a half ago, Walt Whitman wrote in "Song of Myself":

I believe a leaf of grass is no less than the journey work of
the stars,
And the pismire is equally perfect, and a grain of sand, and
the egg of the wren,
And the tree-toad is a chef-d'oeuvre for the highest,
And the running blackberry would adorn the parlors of
heaven,
And the narrowest hinge in my hand puts to scorn all
machinery,
And the cow crunching with depress'd head surpasses any
statue,
And a mouse is miracle enough to stagger sextillions of
infidels.

How extraordinary it is that anything exists, even the least clump of quarks, let alone the profusion of constellations, continents, and creatures we glimpse during our brief lives. How extraordinary that everything from blackberry to black hole is bound together into a single flow, animated by a single energy. All impressions of permanence, all seeming divisions in this torrential flow are only tricks the mind plays to make the world seem tidy and safe. The world isn't tidy or safe; the world is an extravaganza of creation and destruction and recreation. It's a dance of forms, some of them breathing, some of them not, all of them arising and shifting and departing. Of all species on Earth, we humans seem to be uniquely gifted to witness the dance, transmute it through the alchemy of mind, and then to respond with symbolic creations of our own—with stories, poems, photographs, paintings, scientific equations, rituals, songs. Perhaps that's why we're here, to answer the grand utterance of the universe with our own small speech.

The photographs of Darryl Jones gathered in these pages blur the boundaries of things, revealing a mysterious, luminous quality within. Flowers unfurling, corn rippling in the wind, incandescent trees, winding lanes, leaning barns, stalwart tractors, staring cats, grazing horses, everything from clods underfoot to clouds overhead ripples with what Jones calls "the energies of God." Whatever name you give to this pervasive power, you can see it shining through these images, and when you turn away from the book you can see it shining in the world. The closest parallels for this art are less the work of other photographers—although Ansel Adams and Minor White come to mind—than of American painters, especially John James Audubon, Thomas Cole, Frederic Edwin Church, Winslow Homer, Thomas Hart Benton, and Charles Burchfield.

The companion poems by Norbert Krapf draw inspiration from the photographs as well as from the poet's lifelong devotion to the culture and countryside of Indiana. Ranging from haiku-like maxims to brawny catalogues reminiscent of Whitman, by turns wry and soulful, these poems link the exterior landscape of pumpkins and pumps with the interior landscape of memory and emotion. Like "Corn Syllables," which ends as "a hymn / of praise," all of these poems may be read as psalms, hymns of wonder and delight. Those with an ear for American poetry will hear echoes not only of Whitman but also of Emerson, Thoreau, Dickinson, Sandburg, and Roethke, and those with an ear for poetry from across the sea will hear echoes of Blake, Lawrence, and Rilke.

Readers may notice that Jones and Krapf deal only with pastoral and small-town Indiana, ignoring the blight of billboards, cell towers, strip malls, junk-filled ravines, sprawling subdivisions, belching smokestacks, and oil-slicked rivers. These photographs and poems rarely show anything newfangled or troubling, yet what they do show is illuminated by a wisdom that will outlast the industrial blight, a wisdom that could help us to heal our land and our lives. *Invisible Presence* is a religious book, not in the narrow sense of offering a creed but in the broad sense of offering a vision of wholeness. *Whole, holy,* and *healthy* all spring from the same root, which means sound, uninjured, happy. If we knew with utter conviction that each of us flickers up from the one holy fire, how could we devote our lives to getting and spending? If we knew in our depths that the universe is a creation, the outpouring of some sacred power, how could we continue to deliberately harm one another, our fellow animals, or the earth?

In the poem "What if Fish?" Norbert Krapf poses a question that reveals the essence of his collaboration with Darryl Jones:

What if a poet
built gingerbread houses
made out of words
that when you ate
them gave you
the power to create
an Indiana epic

& a photographer
transformed every
image into a painting
that gave you
the capacity to see
spiritual presence
in all things Hoosier?

Those of us who live in unspectacular landscapes—like Indiana, or for that matter like most of the Midwest—landscapes without mountains or canyons, without towering waterfalls or stony coastlines—may be especially prone to lose our sense of awe. Our senses may grow dull, cutting us off from the radiance that surrounds us, fills us, *makes* us. We can be grateful to Darryl Jones and Norbert Krapf for helping us to see spiritual presence not merely in all things Hoosier but in all things.

PREFACE

THE PHOTOGRAPHS in this book represent a departure in style from what I have shown in *The Spirit of the Place,* yet they are, in fact, another means of expressing the contemplation of creation as theophany. The following explanation accompanied my first exhibition of these new impressionistic images, when I contrasted the two styles:

> I use the camera's ability to faithfully record the scene before me. The attempt is to be as literal as possible so that the viewer can have the experience of seeing the beauty and harmony that initially attracted me. My hope is that the viewer will recognize nature as theophany—the formless appearing in form, the visible as manifestation of an invisible Presence. These new photographs are taken with a Polaroid SX-70 camera. I begin to manipulate the dyes under the surface of the print while the image is still developing, using a variety of tools—stick or stylus, etc. to obtain different results. This means that I am interacting intimately with the lines and forms to produce a non-literal representation. These are complementary approaches to express the Spirit of the Place.

<div align="right">Darryl Jones, Bloomington Voice, November 20, 1997</div>

<center>✳ ✳ ✳</center>

To think of creation as theophany, ultimately, is a meditation upon the words of Saint Paul in Romans 1:20, where he writes, "For the invisible things [attributes] of Him from the creation of the world are clearly seen, being understood by the things that are made, even His eternal power and Godhead; so that they are without excuse." It might seem contradictory to say that the "invisible" can be "seen," but this is precisely the heart of the visible.

God is the Absolutely Absolute Undifferentiated Divine Essence, and in His Undifferentiation one cannot speak of an inside or outside, nor of place or no place, for God is All in All. The first differentiations, the first inner articulations of the Divine to Himself, the first movements within Himself are the Logos and the Holy Spirit, the Logos being the only-begotten Word of the Creator and the Holy Spirit proceeding from the Creator as His very life; these are the energies of God.

God is the Hidden Treasure and desires to be known—to share His love, wisdom, and hidden beauty, and so He creates through the Logos and the Holy Spirit. The opening verses of John reveal this: "In the beginning was the Logos/Word, and the Logos/Word was with God, and the Logos/Word was God. He was in the beginning with God. All things were made through Him, and without Him nothing was made that was made. In Him was life, and the life was the light of men." *Logos* means not only Word but also Wisdom and divine Reason, the divine principle of all things. The ideas of everything to come into existence are united synthetically in the Logos in undifferentiation; creation signifies the differentiation of those ideas onto

relative planes of existence—the spiritual, psychical, and physical. "Creation" is the translation of the Greek term *logikos,* so all creation, then, participates in the Divine Logos/Word. The Logos is the Origin, sustainer, and End, the alpha and omega of all existence.

All creation, from the angels to the material world, would have no existence did it not participate in the Logos. Manifestation is the showing forth of the wisdom and beauty of God into what appears to be a separate existence. God is Being Itself, and creation participates in Being, for creation does not have a separate, distinct existence apart from Being. The invisible attributes, the names and qualities of God, are revealed by creation; they are given form and body with creation. Every creature, every species is a manifestation of a unique combination of the names and qualities of God—the energies of God; yet these energies remain hidden as the spiritual essence of each creature.

God is mysteriously present with His creation as an Invisible Presence. The inward nature of God is revealed in the outward; the Outward is mysteriously the Inward. The physical ability of eyes to see the outward form of things needs to be informed by the Divine Spirit within, transforming the knowledge of the outward into a spiritual Divine Knowledge of the Inward, uniting Inward and Outward into One Vision.

This requires a synergistic activity on the part of humankind, which was created in the "image and likeness" of God. The Archetype of Man is the Infinity of the Logos, and Man bears within himself the Spirit as his true Self. But when one sees and is attracted only to the outwardness of things, the knowledge of the Inward is eclipsed as one becomes self in opposition to Self. One's knowledge of the outward will be only partial if one does not see the outward as the visible expression of the Inward. This eclipse of spiritual knowledge can become habitual unless one responds to God's call, and the great Revelations give testimony to the desire of God that none should perish.

God is always present as the great Invisible Presence within all creation, within the spiritual heart/essence of all creatures.

His Outward Revelation can reawaken us to the Inward Revelation, uniting self to Self in union without confusion, providing that we are receptive to the Divine Initiative—God initiates, we respond. One's response is faith and prayer. Our prayer can become a contemplative attentiveness to Divine Love, Knowledge, and Beauty—this transforms the outward into the Outward imbued with the Invisible Presence of the Inward.

> O Heavenly King, Comforter, Spirit of Truth, Who art everywhere present and fillest all things, Treasury of Good things and Giver of life: Come and dwell in us, and cleanse us of all impurity, and save our souls, O Good One.
> From an Eastern Orthodox prayer book

* * *

In the "Photographer's Preface" in *The Spirit of the Place* I wrote about my purpose in taking photographs as follows:

> Therefore I now have to say that my photographs are representations of contemplative studies on the metaphysics of nature as theophany. By "representation" I mean the visual result of an inner study. I cannot explain what I am experiencing directly, as much of this contemplation is an interior experience, but at least I can show in as direct [a] manner as possible what it is that I am seeing with my two eyes.

I attempted to be literal in my approach, carefully using all of the camera's controls to record accurate depth of field with great sharpness and clarity. I wanted the outward to be seen and appreciated for its beauty and harmony.

By 1997 I was experimenting with and exhibiting two other methods of creating images that might appear to be contradictory but were, in fact, complementary to a literal rendition of the outward world. These both involved the use of Polaroid materials either to transfer an image or to manipulate an image.

My first images utilize the transfer technique, whereby a Polaroid peel-apart film is separated before the colors have developed on the supplied paper. I start with a 35mm slide and

place it into a daylight enlarger designed for the Polaroid film. After an initial exposure and subsequent pulling of the film between two rollers, thereby breaking a pod containing the color dyes, the paper with the dyes is separated and transferred to a new paper—watercolor paper, for instance. Once the dyes have migrated to the new carrier paper, the old paper is removed, leaving the image on the new carrier. This is not an easy process and requires much patience and experimentation. The images are unique, as the process cannot be duplicated precisely. Sometimes the edges of the image tear away and become indistinct, making the borders appear open. Other photographic processes, such as the Polaroid manipulations, produce prints with distinct, sharp borders, making a boundary around the image. The colors on the transfer paper are somewhat muted, because a portion of the dyes remain on the initial Polaroid paper. The rough borders and muted colors seem, to me, to be representative of a remembrance of things past, or of a dream that is recalled but not distinctly, where colors are not bright and vivid. Yet, the dream is important, and one does remember.

Manipulation prints require entirely different film and techniques. I use the original 1972 Polaroid SX-70 camera and what is now called "Time-Zero" film. This revolutionary camera is a single-lens reflex that allows the photographer to see the image in the viewfinder and to focus on exactly what he wants in the final image. After exposure the film is automatically fed through two steel rollers which action breaks a pod containing silver development chemicals and color dyes. The image develops to completion in several minutes. There is no transfer to another paper as in all previous Polaroid processes. Early users discovered that if they were not careful with the developed print and accidentally touched the surface (perhaps leaving it in their top shirt pocket), they would find the images of their relatives and friends blurred and distorted. The dyes did not harden until about 24 hours had elapsed. This drawback became an advantage for photographers who wanted the ability to manipulate the dyes for artistic purposes.

The technique is reminiscent of open-air painting, for after I have taken the photograph I stand in front of the original scene while I am working on the print. I use numerous devices, such as a stylus, to press upon the surface of the print, applying the necessary pressure to move the dyes beneath the protective surface. Experimenting with different styluses and hand/stylus-pressures I realized I could produce dramatically different results. My friend Stuart Wetterholt carved for me a set of three styluses, with different shapes at each end, giving six possibilities. He also repaired a wooden box to store these and a handwarmer, which I use in cold weather to keep the dyes pliable.

An early lesson was very informative and gave me new insight into the possibilities of the process. On a windy, rainy Owen County fall morning I was driving past a cornfield ready for harvesting. I watched the wind blow the cornstalks, and I tried to capture the bending of the stalks. As I was working with a stylus on the corn, I wondered how I should treat the gray sky. What type of lines or shapes should I work with? Just then, the gusting 40-mile-per-hour wind pushed my hand across the sky of the print. Another gust again moved my hand, and now the wind had acted to produce its own desired effect. This was amazing to me, for this was a synergistic action that intimately related me to the forces of nature. The image shows a sky that is as dramatic as it felt upon my hand and face. In a sense, the hidden energies were revealing themselves, the inward was being conveyed by the outward.

The resulting image is only a representation of what I experienced, an impression of the experience rather than a literal presentation of the scene before me. Instead of detail, I work to reveal the essential, underlying form. The movements of my hand sometimes produce swirls that are in keeping with the hidden energies. I always appreciated the Impressionist painters who looked for form and bold colors, but now I feel as if we are kindred spirits. I do not attempt to copy any specific style, but let the forms and energies determine the result.

ACKNOWLEDGMENTS

SOME OF THE POEMS in this book appeared in *Branches* and *The Raintown Review* and the anthology *For Loving Precious Beast* (Purple Sage Press, 2006), edited by Yolanda Coulaz. Thanks to the editors.

The photographer and the poet wish to thank their friend James Alexander Thom for insisting, at the 2004 Holiday Author Fair, Indiana History Center, that "they must do something together." Thanks also to Linda Oblack for her persistent humor and unflappable confidence that it would all happen.

I. ALONG THE ROADS

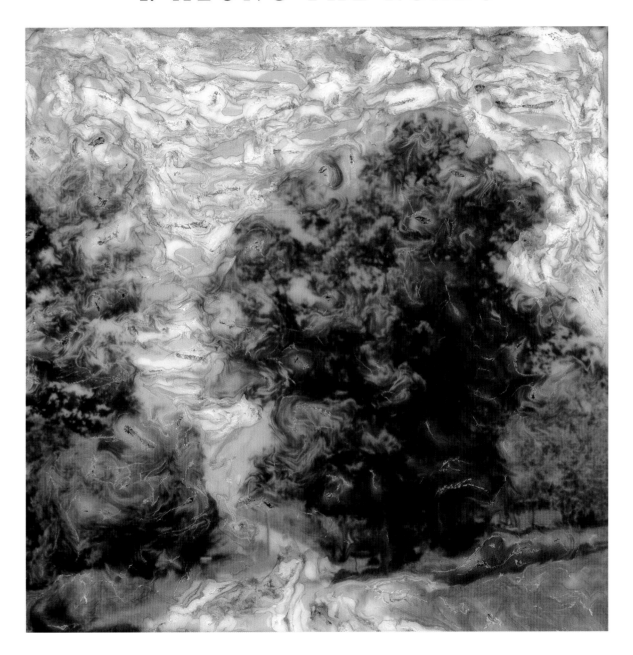

Gate

It's not what's
in a gate so much

as what might
lie beyond it

makes us want
to push it open.

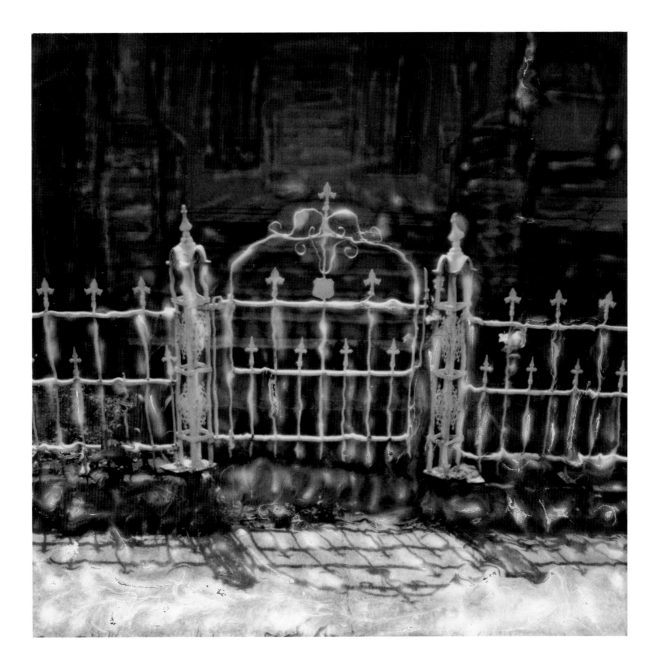

The Language of Red

To walk under a tree
that is on fire with color

is to feel yourself purified
of all that is lumpen and stagnant

& be released into a realm
where all is elevated to spirit

& you are free to climb
beyond where you have seen

& you sense you have just
begun to reach levels of approach

that open into paths & roads
you had not even imagined

& know that now you
are prepared to speak

a language that is flame
burning higher & higher.

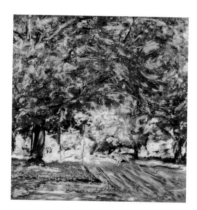

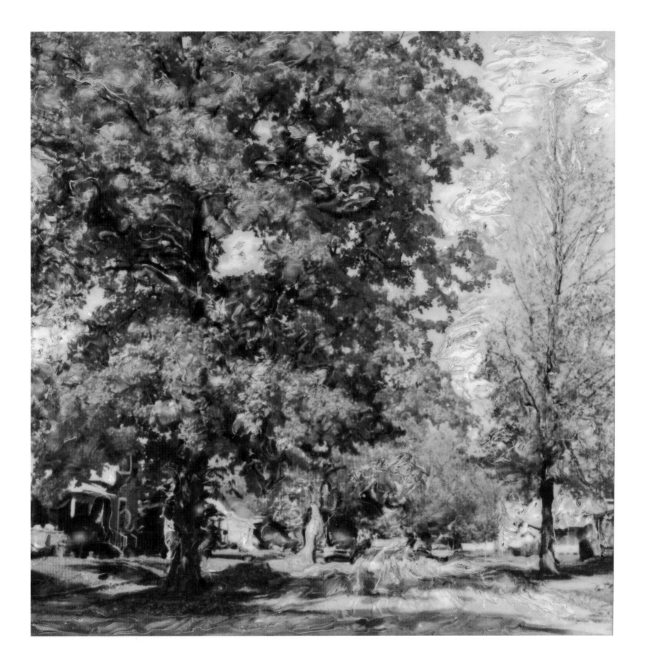

Corn Blowing in the Wind

Just before harvest time
I was driving along a back

road & the voice on the radio
said the wind was gusting

to forty miles per hour or more.
I pulled over and got out

& stood at the side of the road
to witness and watch cornstalks

bend over as if they were yielding
to the gods everything that had risen

up in them from the ground.
I felt myself lean with them

& knew that a force bigger
than myself ruled from beyond.

I felt my hands move with a will
not their own, my eyes saw

movement they did not usually perceive,
my ears heard sounds they did not

normally register, & I wondered if
the divine breath I had heard about

was touching down to burn my lips
& turn me into an Indiana Isaiah

who would breathe yellow flames
and speak in backwoods tongues.

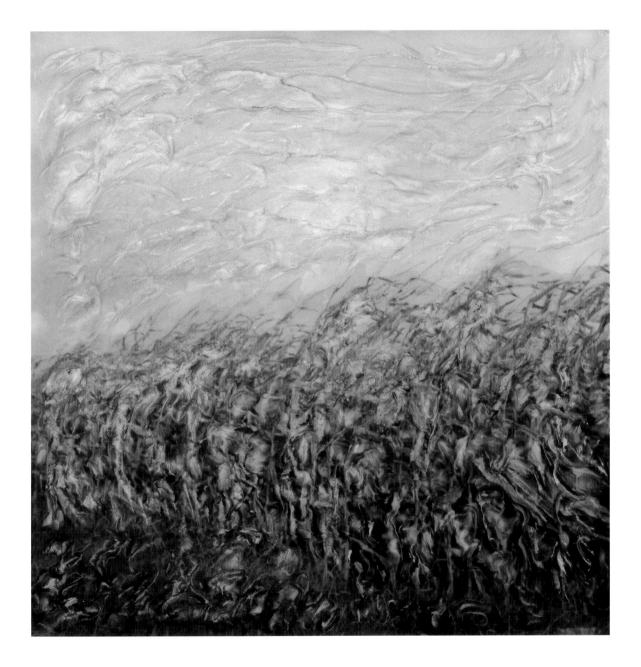

Someplace Good

Any rock road that hugs
a woods on one side

& a field of golden brown
cornstalks on the other

& takes you beneath
folds of crimson leaves

& makes you listen
to the crunch of black

tires on white rock & hear
the ping of something hard

against a floor of metal
beneath your feet & lets you

look up to black wings soaring
between white & gray clouds

overhead has to lead
to someplace good.

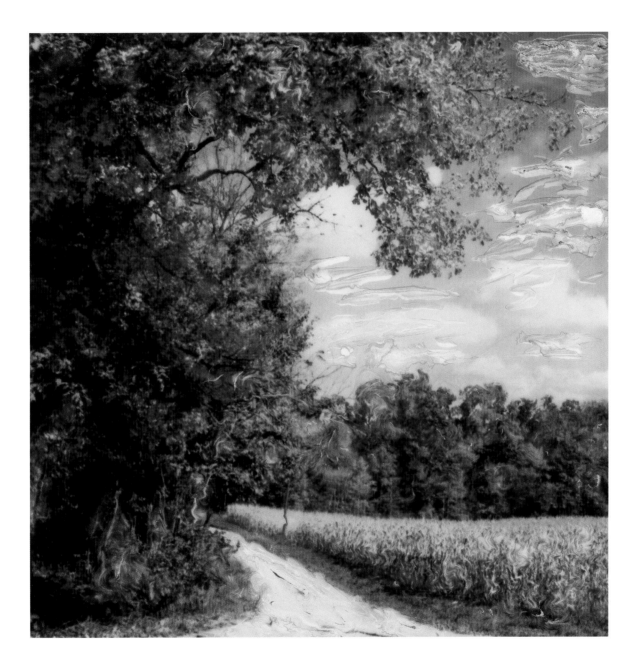

Curve in the Road

The way a road curves around
between woods & a field
of corn where a patch of

milkweed sends out fuzzy
seed into the warm air
says a lazy fox squirrel

cuts on a hickory nut
high in his favorite tree,
a farmer feeds squealing

hogs down the road
a quarter of a mile,
& a heavy-set woman

stands at the kitchen sink
washing breakfast dishes
hearing the advice her mother

gave her about raising
a family & where life
might lead that is not

all straight stretch but
includes more than one
or two blind curves.

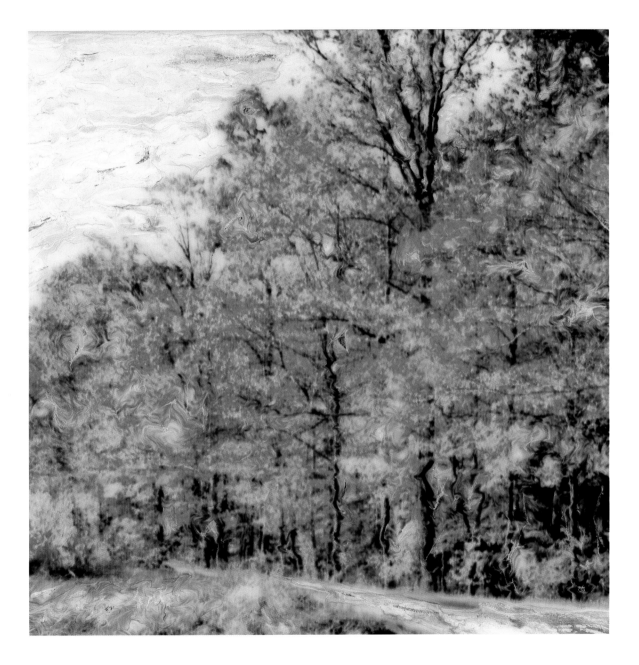

Shady Curve

When you approach a curve
where leafy boughs hang over

& shadows play on the road like
animals vying for your attention,

you slow down until you
reach the middle of the curve

& then accelerate as you
feel yourself pick up traction;

but you never know for sure
what lies beyond or may be

coming toward you, even if
you have driven this road before,

& so you keep your eyes open,
although you cannot see far ahead,

& hope & pray that vision & memory
& a feeling of control that your hands

convey, as they grip the wheel, bring
you safely to wherever you are headed.

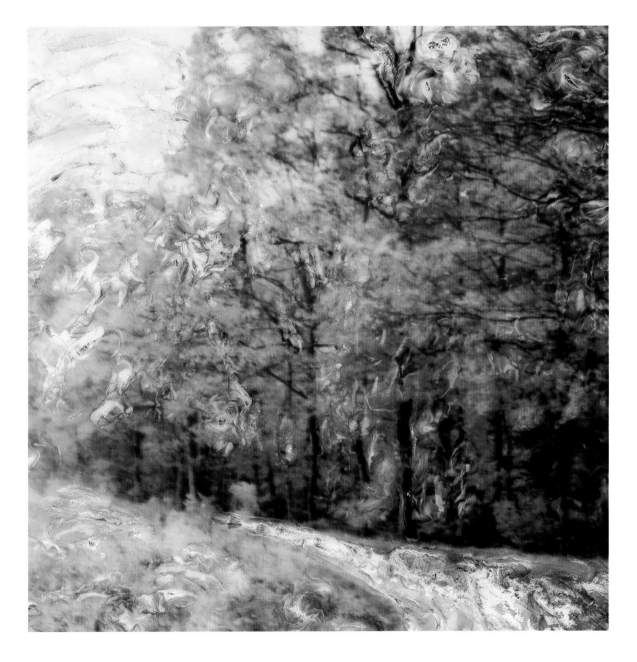

Shady Road

Walk down this road
with me in shade.

Leaves will rustle
above our heads

like green semaphores
from a presence beyond.

Every once in a while
our feet will find sunlight,

then return where we belong.
When we come to the bend

in the road, don't be
surprised if I disappear

& lie down in the barn.
Animals will feel my

spirit stir & stand when
it is released at dawn.

 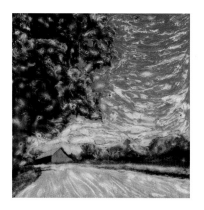

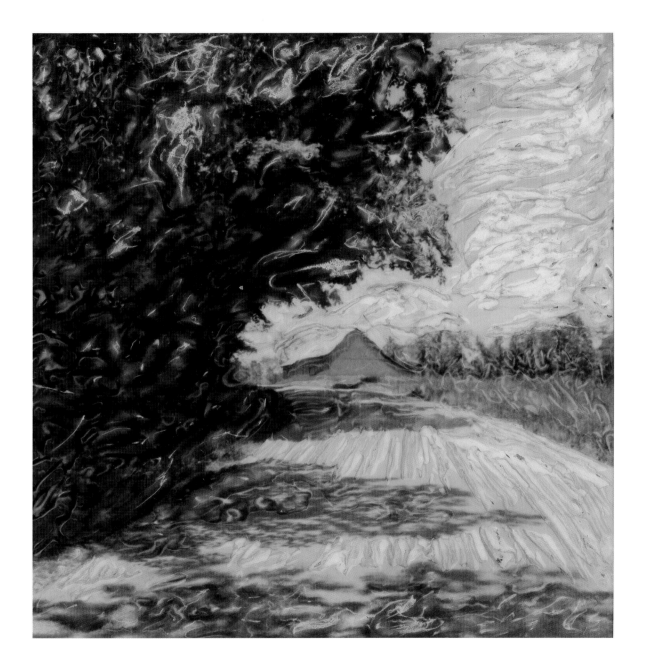

On Wide Waters

To ride all day in a wagon
with all your cousins & friends,

pulled by a tractor driven
by somebody's dad or big brother,

in & out of the shadows,
as dry leaves crunch beneath

rubber tires & sunlight sometimes
splashes on your hands & face,

is to float away on waters
as wide as the whole world

& believe that this time
you are enjoying with others

will never end, until you see
a faraway shore coming near.

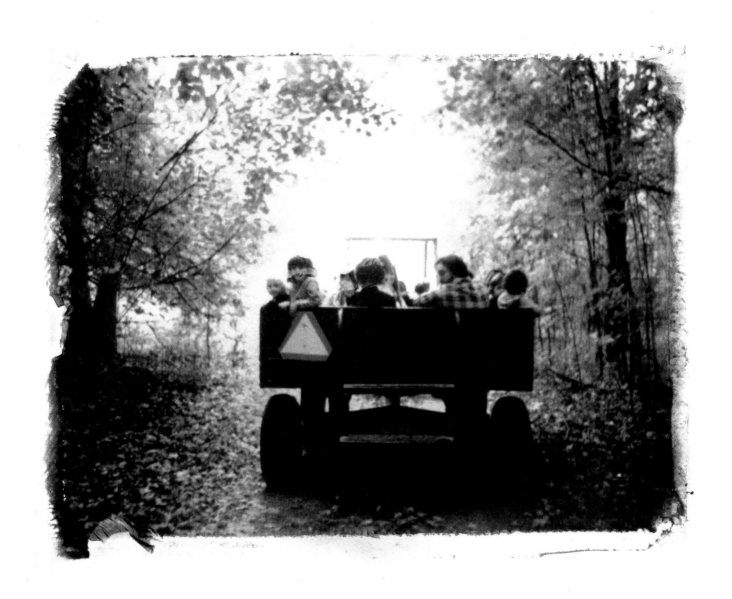

Straight Road

If a road
looks straight
too far ahead

it can waver
beneath you
before long

& make you wonder
why you have
lost your bearings.

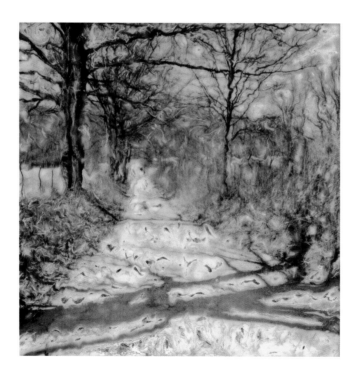

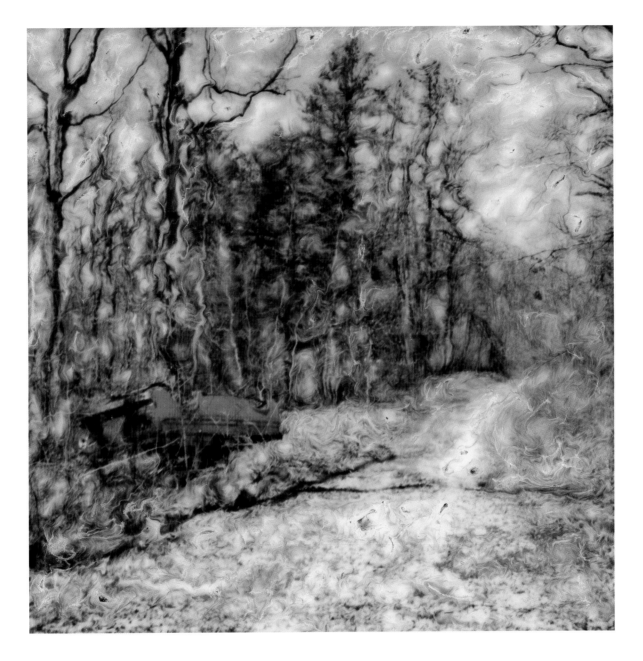

Under Crimson Leaves

When you drive
under crimson leaves
that cleave late

you know you
have been given
a reprieve.

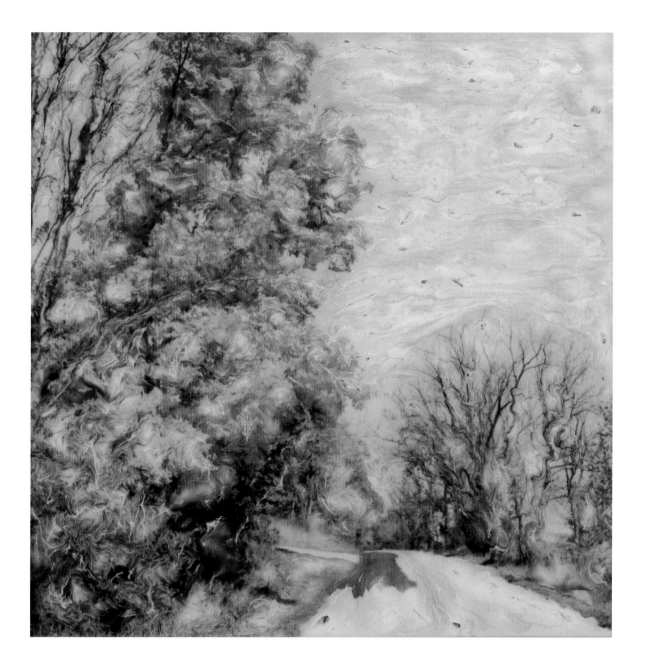

The Blue Road

Will this winding blue road
I have been driving down

for I don't know how many years,
through these deep woods I love,

taking all the steep curves
at just the right speed,

shifting for all the grades,
tapping the brakes as needed,

ever open up into the endless
blue I have heard about

& yearn to see?

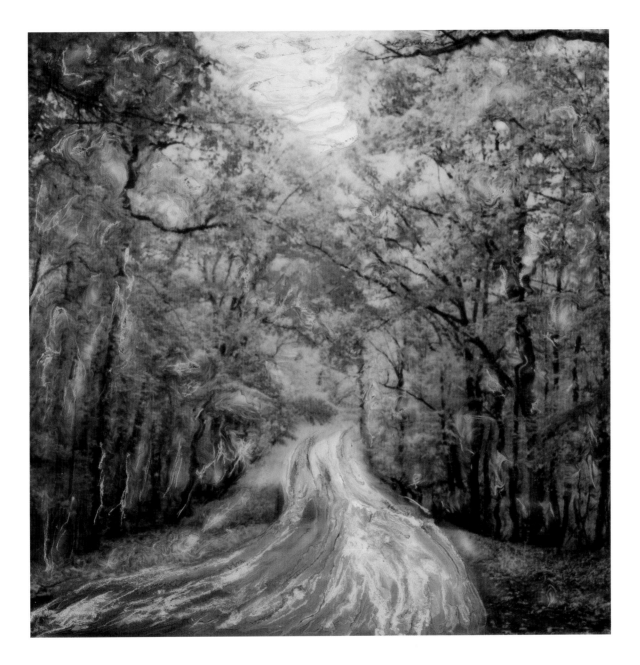

Crest of the Hill

When the wagon
approaches the crest
of the hill

under the leaves
burnished gold
by the sunlight

your life trans-
forms into shadow
& you feel

the spirit world
pull on you like
a home you lost.

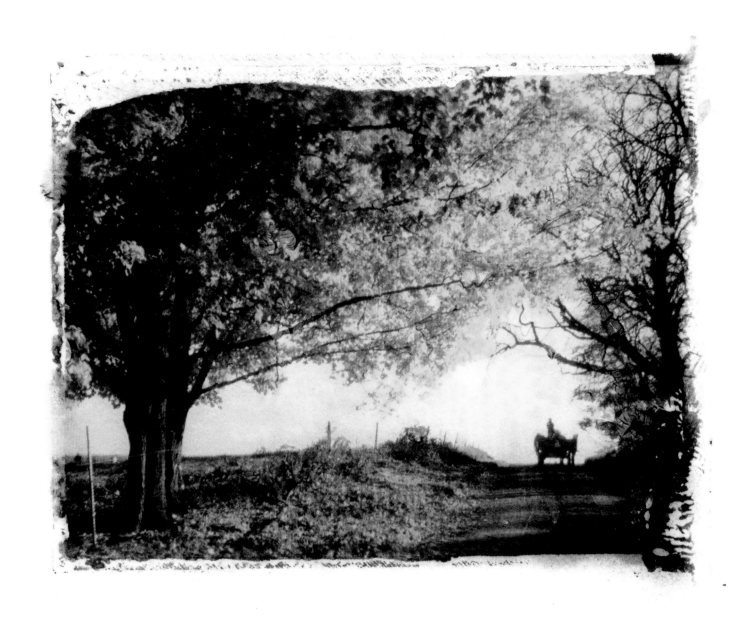

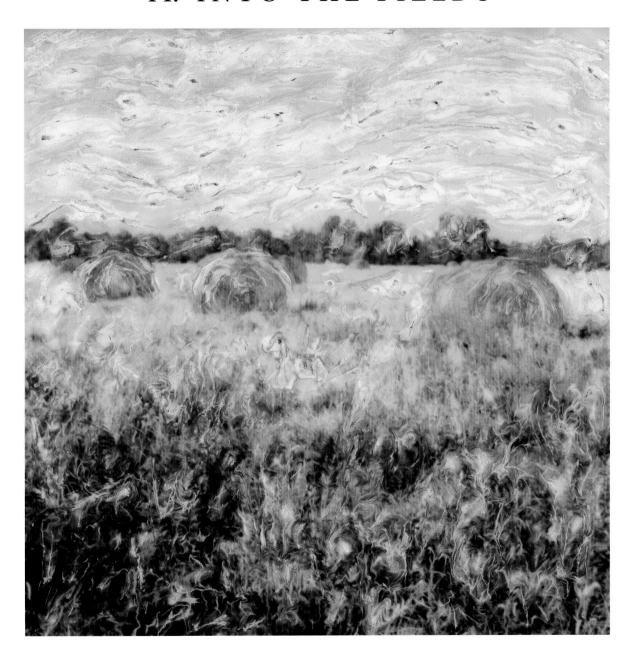

Pasture Scene

In a pasture where
three horses arch
their necks
to the ground

to eat grass,
you are witness
to a dance that has
gone on for aeons

& makes you
want to move
your feet & turn
in unison with the necks

of the horses
& the flow
of the water
at the edge

of the field
& the sky stretching
beyond over fences,
houses, & trees.

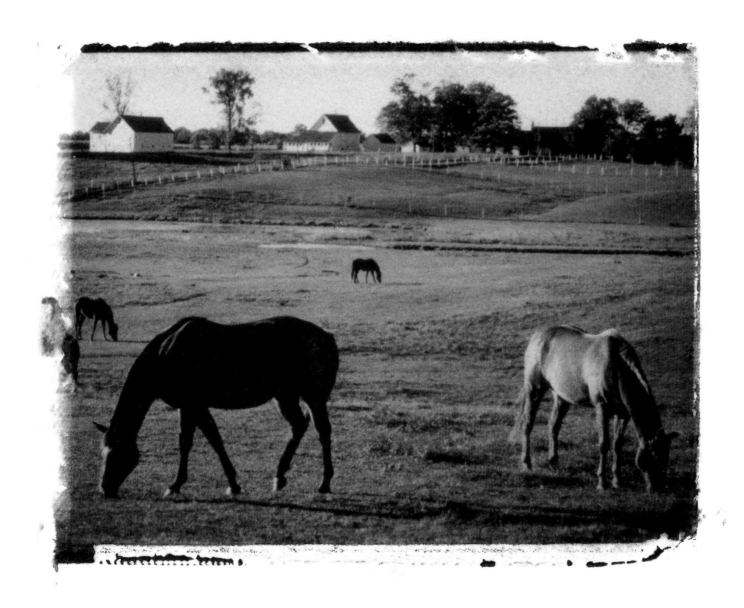

The Space Between

The space between
the noses of
a mare & her foal

who arch together
in a field
beside a fence

is the distance
between two worlds
reduced by love.

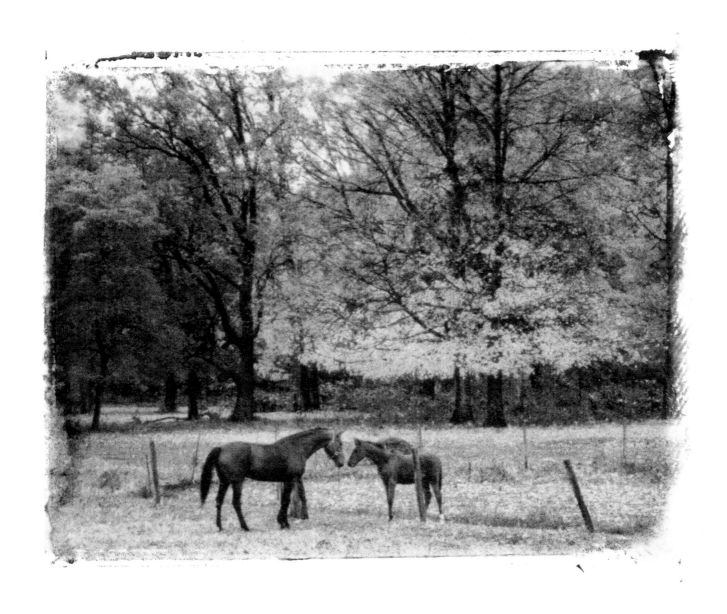

The Sound

The sound
of a horse
munching grass

beside a foal
that turns an
eye on you

is the rhythm
of a song
you heard

when your mother
taught you how
to eat solids.

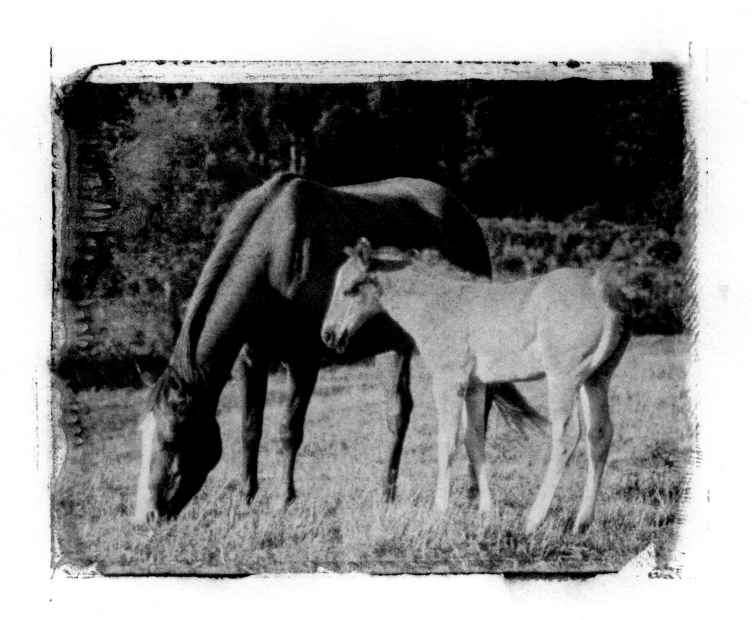

Horse & Tree

To stand in a field
between a dead tree

& a living horse
who stares at you

as you look at him
while both of you breathe

makes you think
of slowing down

what you do so
you can comprehend

how & why you live
& what it might mean

to take a breath
you draw from air

in a field in which
you stand looking

between a dead tree
& a living horse.

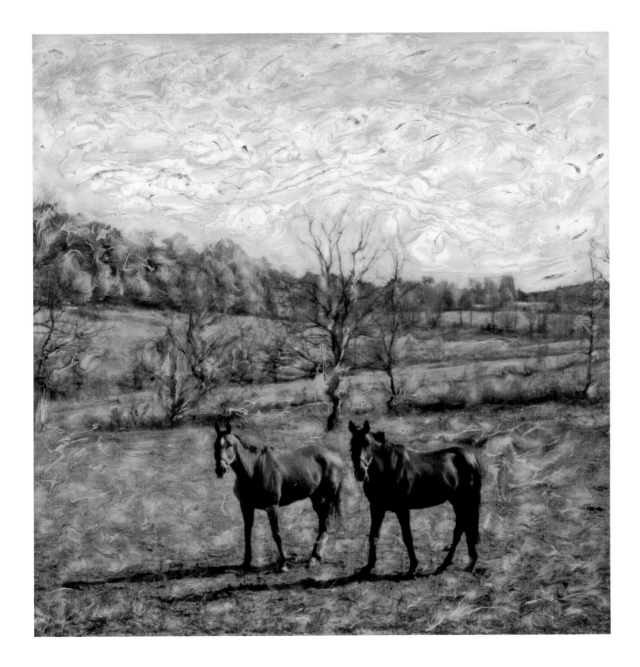

Field of Motion

The way a horse
gallops down a slope

with its neck arched up,
its tail thrown back,

its mane splayed up
& its legs bent

at just the right angles,
makes it move forward,

yet stay still, in motion,
forever, in our eye.

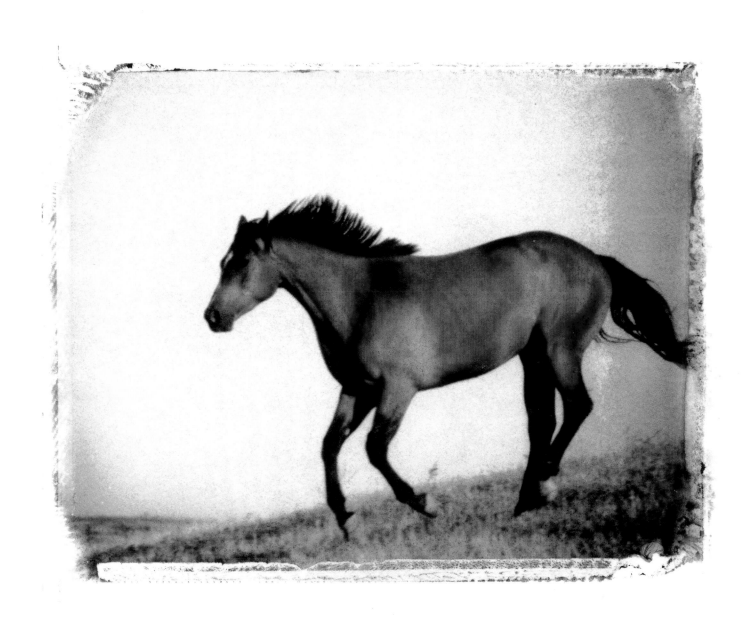

A Woman on a Horse

A woman sits in the saddle
of a rippling horse standing
between two bare trees.
She points her crop
at something we cannot see.

What is the name of what
she sees but we cannot?

Should we give a name
to what we cannot see?
How do we get from
what we cannot see
to what is clear to her?

Is this woman on the horse
more beautiful & mysterious
because we cannot envision
what she can see?

Shall we take bets on what
she points toward & what
she is likely to do and give it
the name of something
we have seen and done?

Or allow the woman in the saddle
on the rippling horse the right
to the mystery of her vision
& the power of her action?

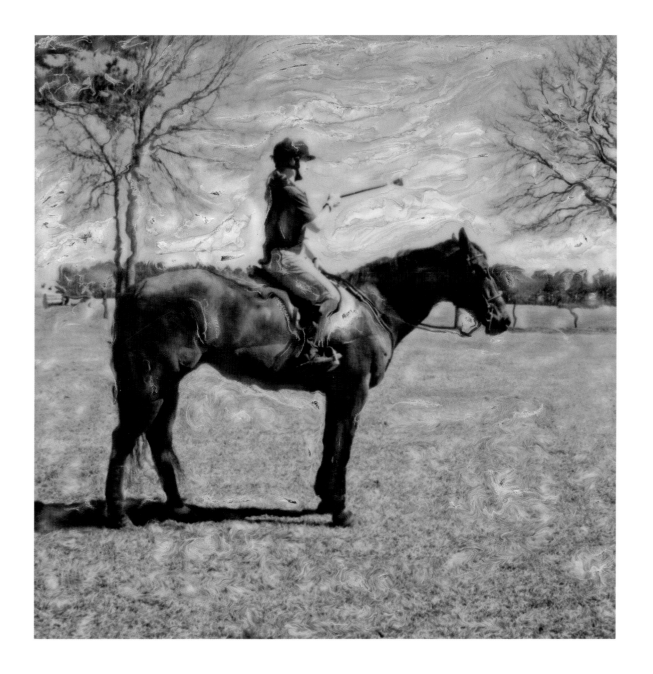

Sylvia Plath's Ride

When Sylvia Plath
flashed into the morning
she was one with her horse,
one with the landscape,
& merged with the sun.

What followed her
was spirit released
into the cosmos

& caught like fire
in the poems
she left behind.

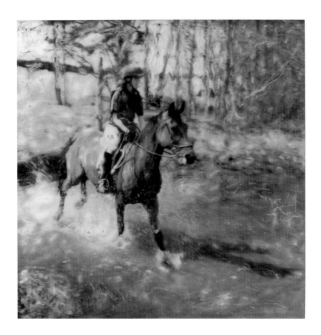

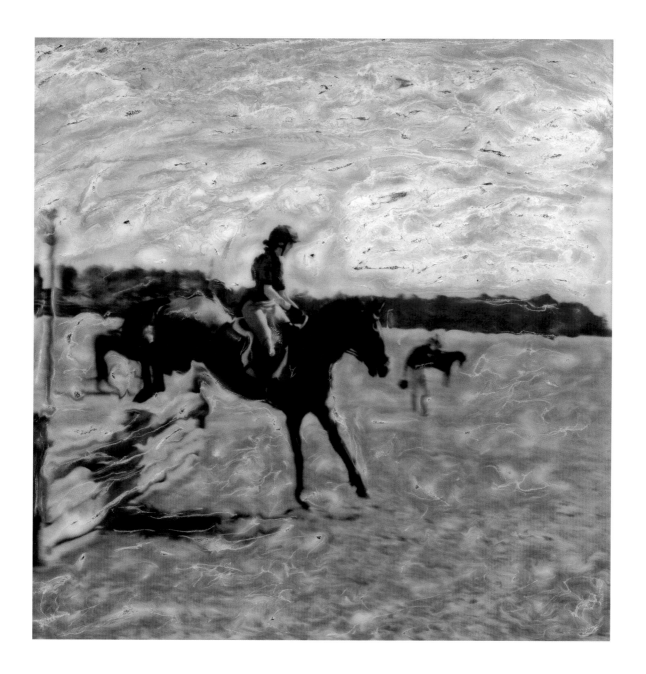

Fog & Mist

Sometimes fog
rolls in the fields

sometimes vapors
drift in the air

& sometimes mist
lies in our eyes.

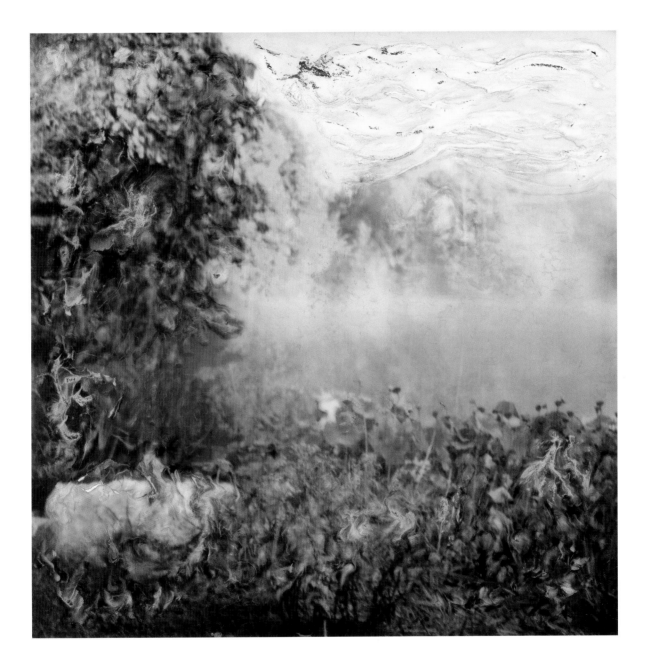

Change

Two black ears
& one black face

turned in
your direction

change how you see
a world of white wool.

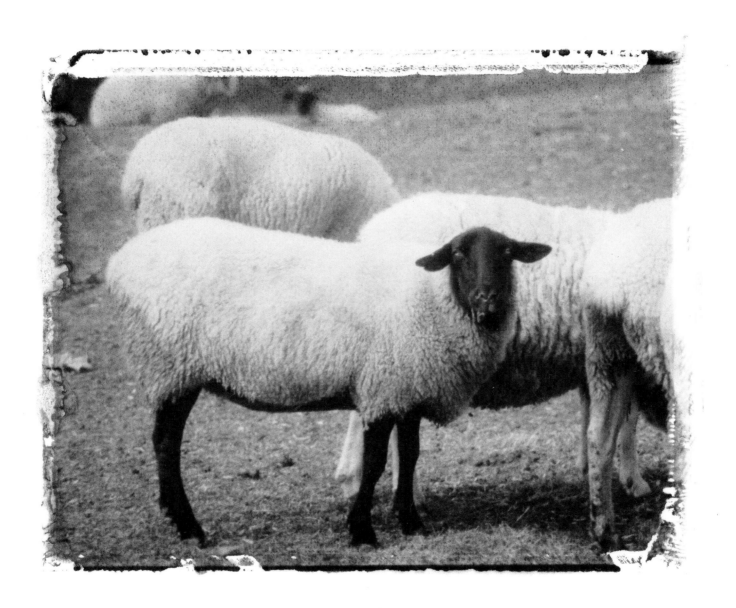

Bovine Beauty

Where do *you* come from
and what the hell do you mean
can you take my picture?
Why don't you pick on
the one standing back there?
Can't you let me chew my cud?
Can there be no peace in the pasture?

OK, show me some real ID.
What's your favorite brand of milk?
Who's your favorite cowboy singer?
Who's the prettiest cowgirl ever?
Did you ever sing that one about
The Little Dogie, around the campfire?

What, you don't eat meat?
Why of course you may, baby.
Just make sure you focus
on these beautiful brown eyes
& send me a print for the calves.

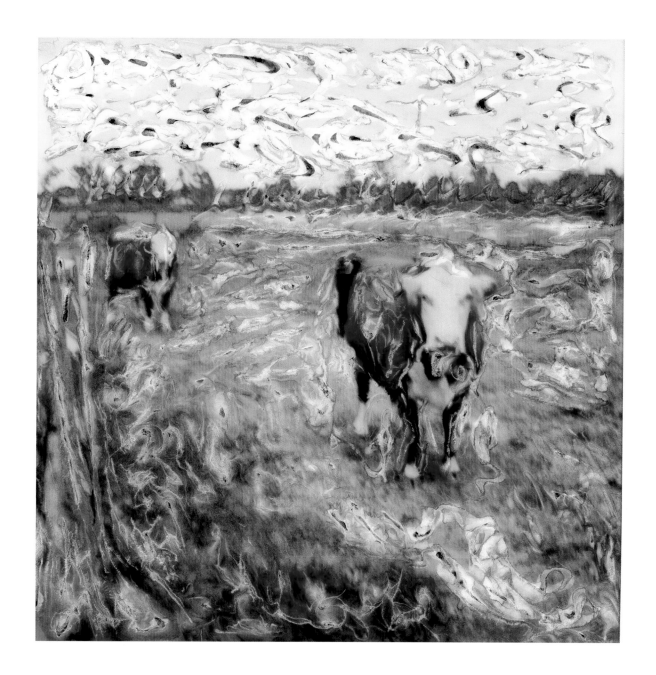

Corn Syllables

Corn can stand
so still under

blue sky &
puffs of cloud

that when any
leaf moves

on a stalk
you hear the

first syllable
of what

builds toward
the first word

of a new
language

in a hymn
of praise.

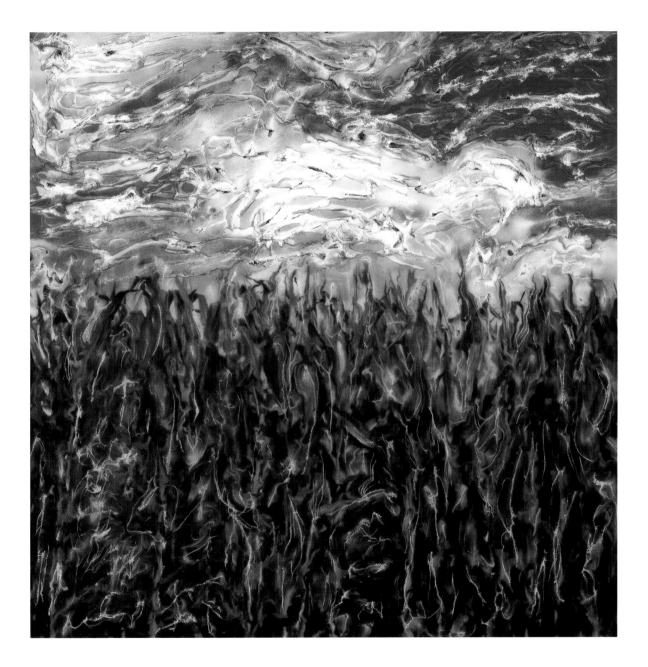

Hay Bale Cycle

Layer & layer
& circle after circle

of alfalfa roulade,
clover wrap,
timothy roll,
& orchard grass strudel

just waiting to be chewed,
compressed into cuds,
worked through the system

& dropped back down
to God's green acres

to become seed for
layer & layer
& circle after circle. . . .

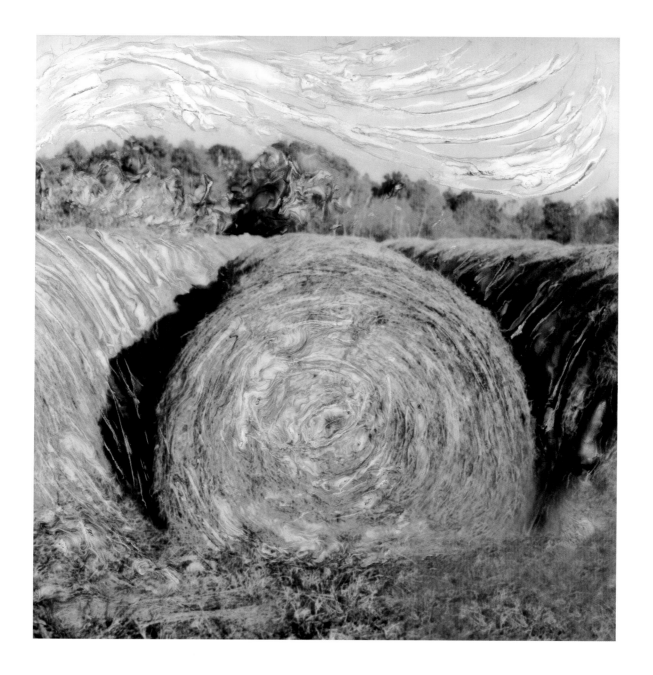

Hay Bales of the World

If you were a round bale of hay
would you want to roll the length
of a field on your own before

you were left to stand in the open
until some animal came on hooves
to chew parts of you into cuds

& shoot you back to the earth
through the other end, or would
you want to unite with fellow

hay bales of the world in a single
field & roll together down
the slope like a full army

toward a red barn which you claim
as headquarters, kick the animals out
into the cold, & vegetate in harmony?

 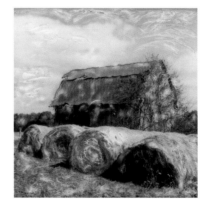

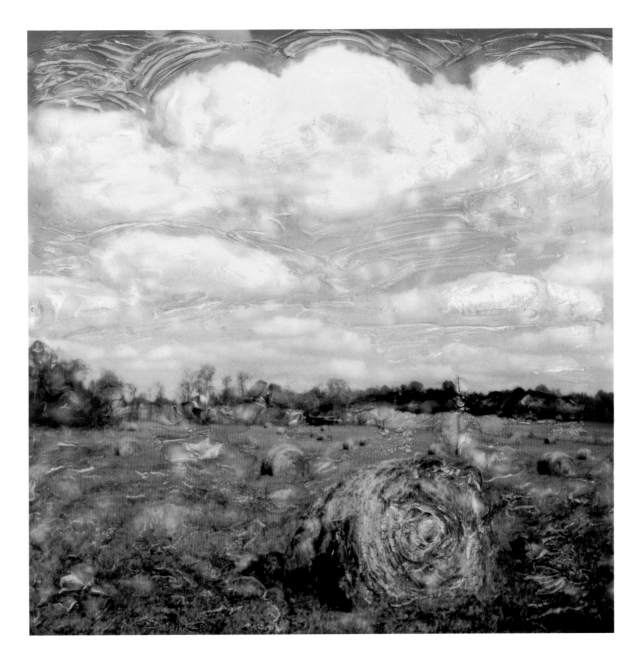

John Deere

A green John Deere tractor,
with bright yellow tire rim,

resting under a green tree,
beside a green implement,

seems as content as a tractor
can be; but then it roars to life

& chugs up & down a field
to slice open moist earth

that will bake in the sun
like rich primeval cake.

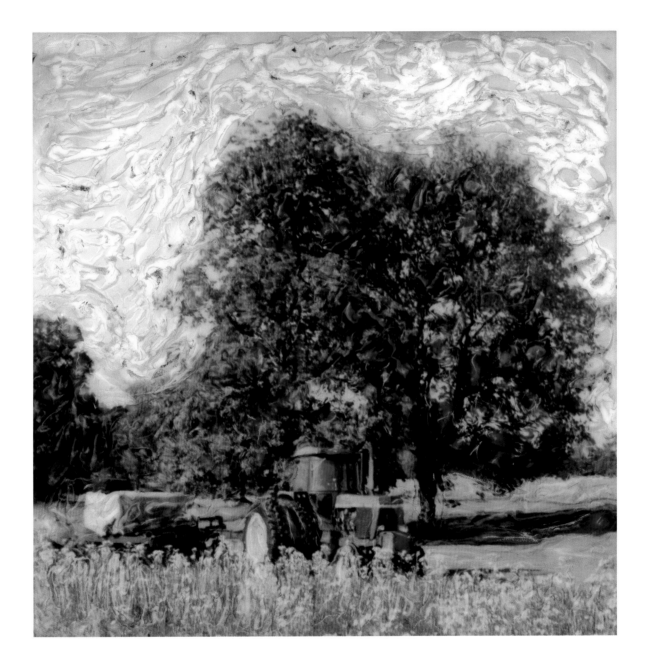

Cut Earth

Where man cuts earth,
lines & patterns show,

but where they lead
how can we know?

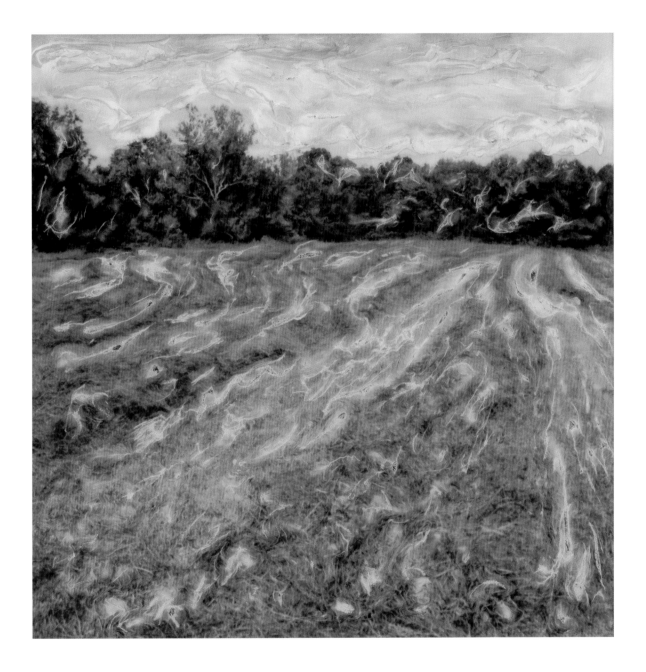

Dark Clouds

When you walk
or drive under
rolling dark clouds

you want to stop
& look up to
figure out how

some of the light
refracted from beyond
could find a way

to touch your
skin & settle
inside your spirit.

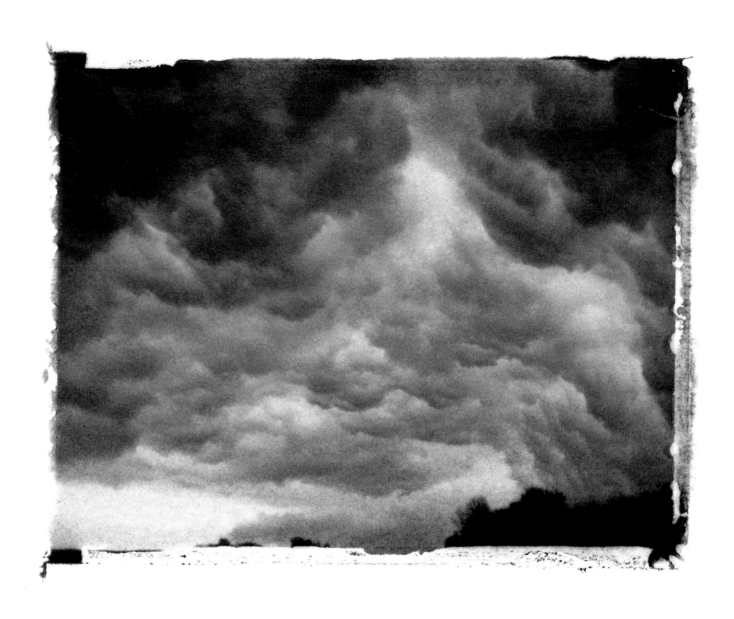

Goldenrod

Before a field of corn stalks
 so pale & dry you think
 they will erupt into flame

 stand two goldenrods,
 their clusters of bright gold
blossoms so thick & heavy

it looks like they will topple
 to the ground like boozing
 buddies on their way home

 from the bar. Because of their
 showy display, they are convicted
of the sneezy crimes committed

by the more modest ragweed;
 but despite the bad rap, they carry
 their passengers, crab spiders

 & blister beetles, into the fall
 & announce with slurred color
that first frost cannot be far behind.

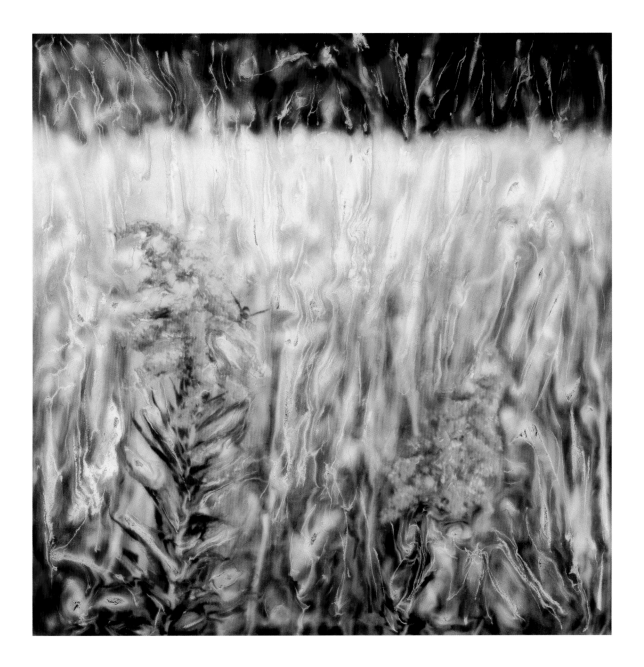

The Cottontail

Beneath & between
briars & bushes
& broom sedge
covered with frost

huddles a cottontail
you & I cannot see.
If the dogs were
dumb enough to be out

on a day like this,
they would jump that
rabbit & bring him
into full view;

but since dogs
are smart & rabbits
are careful,
you & I

do not get to see
the cottontail that
huddles beneath frost
in broom sedge & briar.

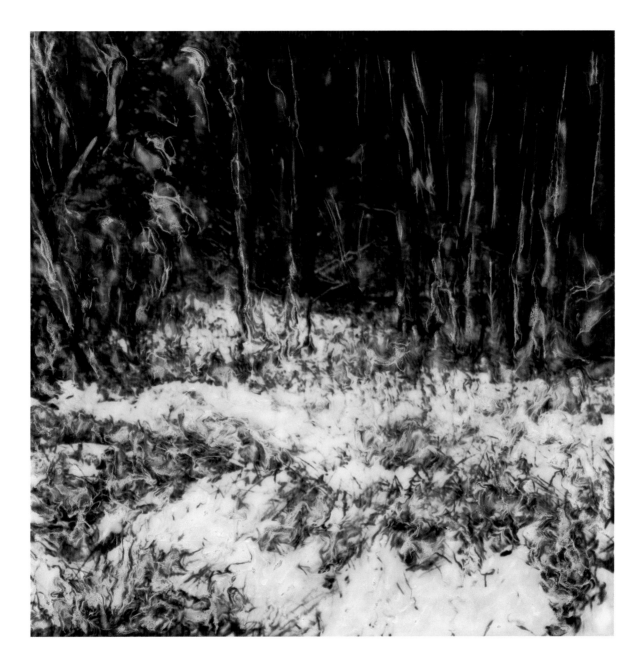

Sky Fire

Fire comes late
afternoon in the sky
behind the house.

The trees catch it,
leaves curl, branches
glow like candles.

All your blinking
eyes can see is
lines of chimneys

& a few charred
poles, like what
was left when that

family's home place
was brought back
to the ground,

& you could
feel the heat
of what melted

everything down
to a silhouette of
what it once was.

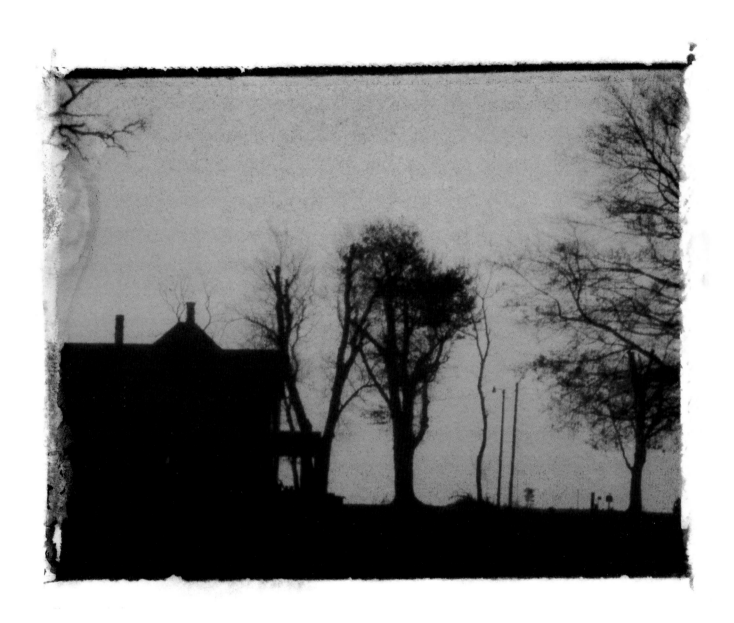

Ice Trees

When that pair
of trees that stand
like guards by the pond

were glazed with ice,
they compressed more light
than any two eyes can hold,

& their branches stood
out like bones glowing
from a world beyond.

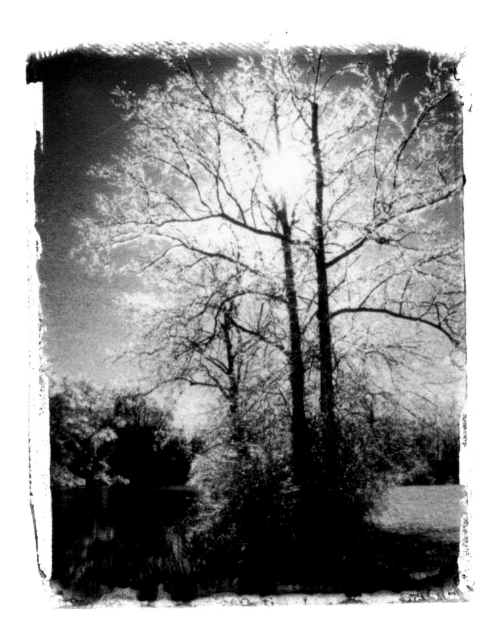

Ethereal Smoke Ring

When I looked up & saw
that white helix of a cloud
hanging way up in the sky,

I asked myself, "Well, why
should God not blow
an occasional smoke halo?"

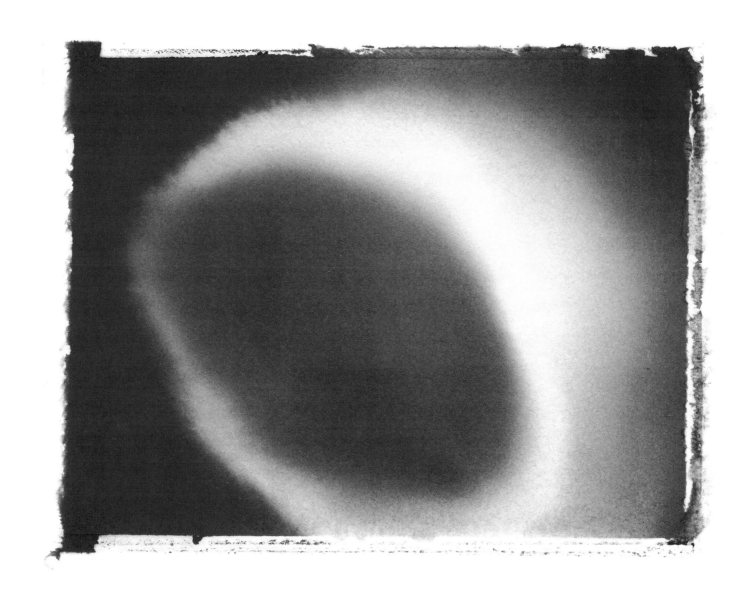

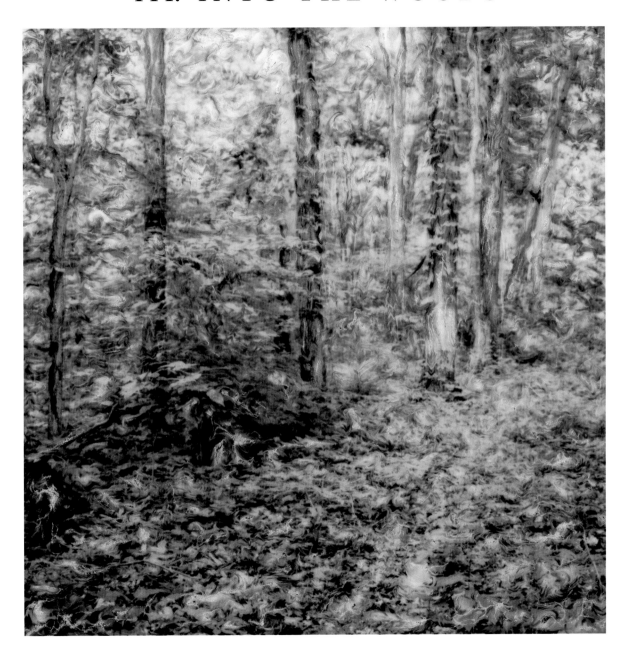

New Leaves

When new leaves
unfurl in woods

sunlight makes
different patterns

on us, small
curlicues of color

hang between us
& the sky,

where we stand
shifts toward shade,

& we feel
layers of presence

grow everywhere
above us.

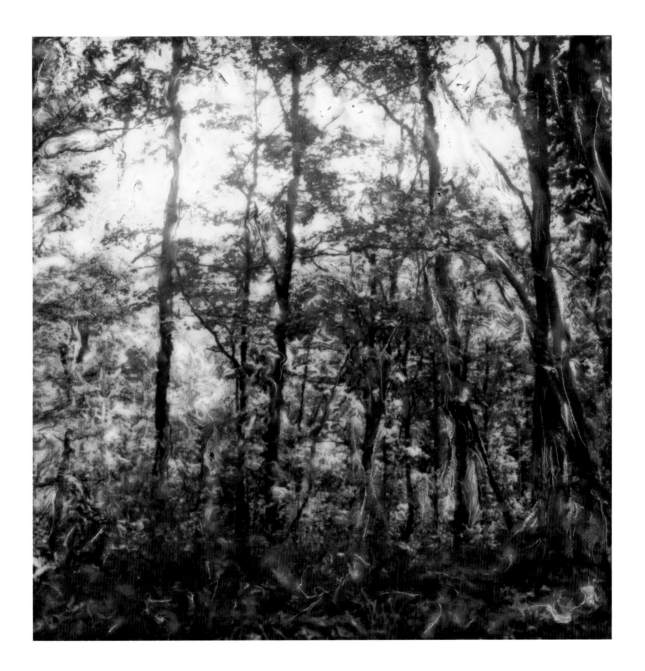

Jack-in-the-Pulpit

Looking down
into a jack-in-the-

pulpit, we slide
along chutes

& stripes
of crystal color

that deposit
us somewhere

in the heart
of matter

where mystery
drops to deeper

& deeper rungs
of darkness.

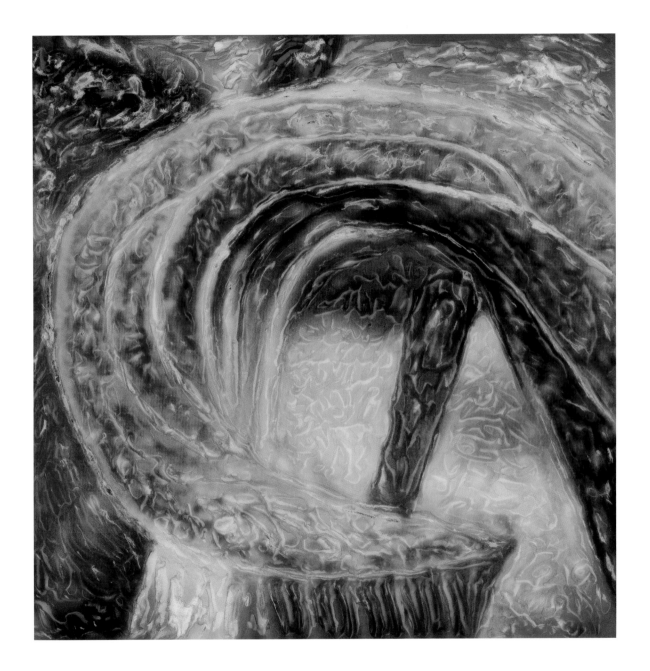

Morel

The mosaics
of a morel

make small
mysteries

loom large.

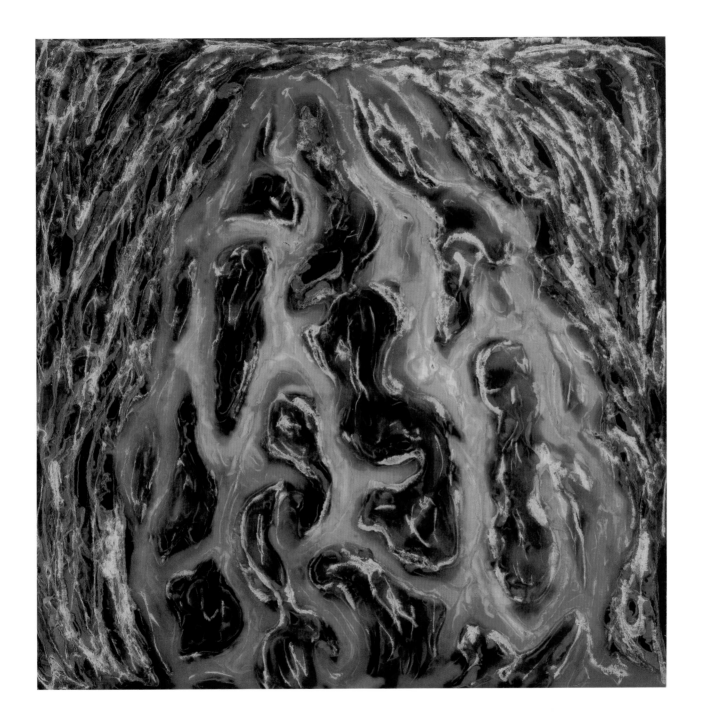

Dappled Leaves

When we stand
in the presence

of leaves dappled
with light we

sense a presence
in & beyond

the light we
cannot define.

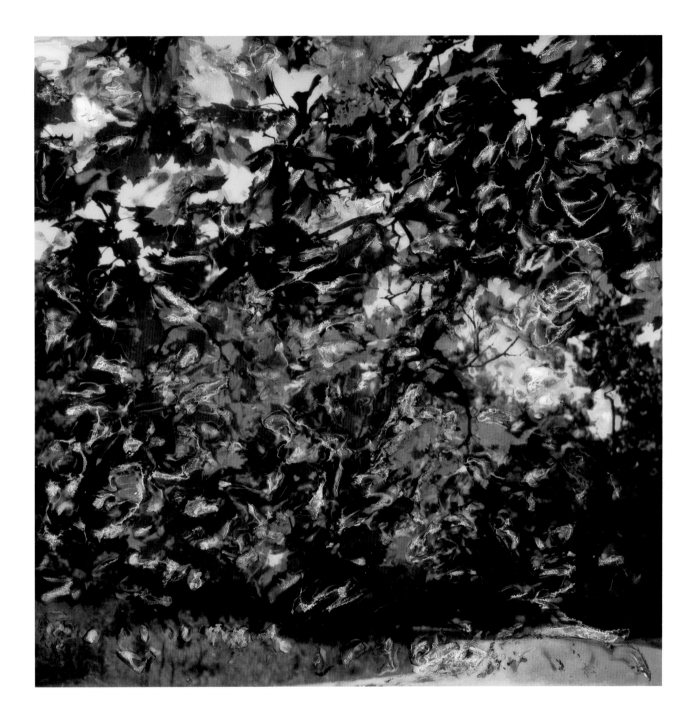

Cabin

I'm going to build a cabin
out in the woods, not far from
the creek & the blackberry patch.

Between the black walnut
& the tall shagbark hickory.
I'll pound in all the nails

with my very own hammer.
Cook everything on a wood fire.
Dry the clothes in a clearing.

No electricity. No phone. No fax.
No computer. No e-mail. No TV.
Maybe not even a radio. I'll bring

a copy of *Walden,* which I'll read
by the light of day, or by candle at night.
You come, too, and I'll read to you,

word by sacred word, the chapter
about how morning brings back
the heroic ages. We'll snuggle

beneath an old family quilt. Morning
sunlight will find & caress us;
we'll baptize one another in the creek.

We'll learn how to consecrate
every minute of every day. Smoke
will rise like prayer up the chimney.

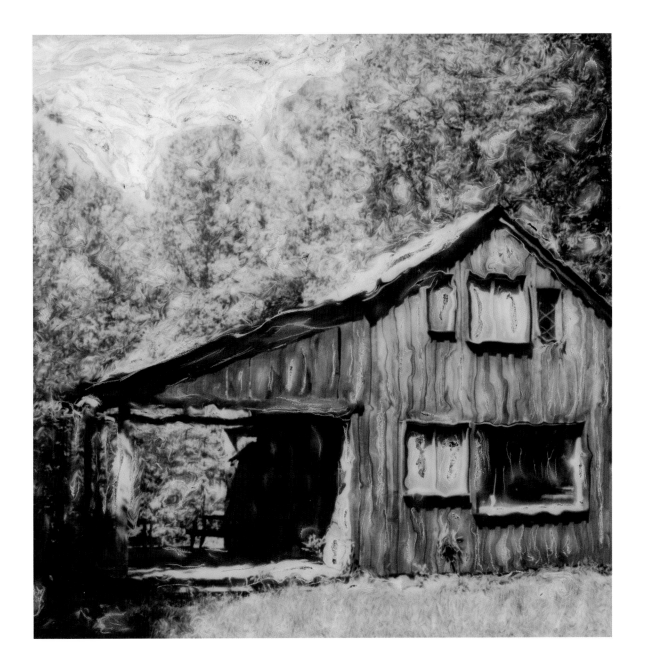

Pickup

Out behind the cabin, in shade,
I'll leave the pickup parked.

It will carry wood I'll split
for the fire. The dog can

curl up in the back when we
go for a drive into town.

We'll leave with an empty bed
& come back with bags & boxes

of provisions for the winter.
When we groan up the lane,

as I downshift & slide in sand,
squirrels will go scampering

& the doves will flutter
up from the cabin roof

to welcome us back. Pure
air will descend upon us.

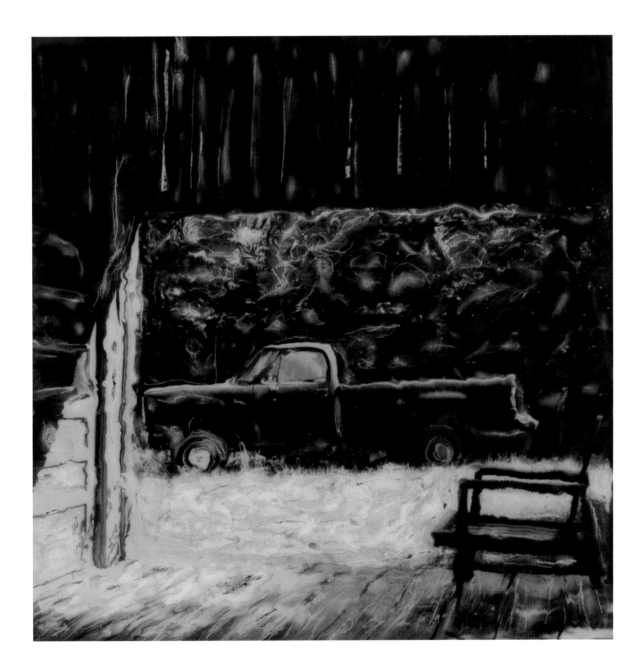

Walking in Woods

To walk in the woods
behind the house

is to step back
into sunlight splashing

through boughs onto
your face, shoulders,

& fingertips & let
yourself hear sounds

of creek water & wind
soughing through leaves

as the dark static you
carried with you fades

& you see mushrooms
at your feet that fifteen

minutes ago would not have
grown in your universe.

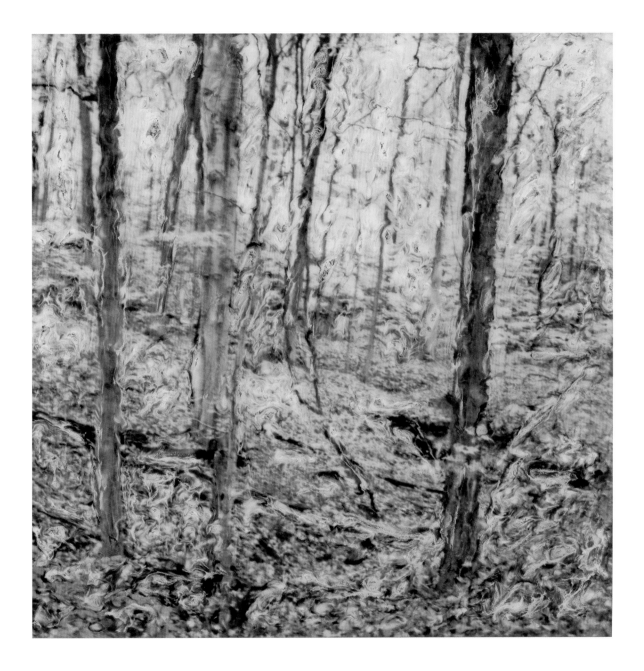

Whitman's Web

When Walt Whitman observed
a spider spinning its web,

he thought of his soul sending
out ductile filaments to connect

with something beyond himself.
Once, walking in the woods,

I found sunshine backlighting
a web & stood transfixed

before a pattern so intricate
I could only give myself to

the design before me & wait
& hope for more light to show

where the intersection of gossamer
threads & my path may lead.

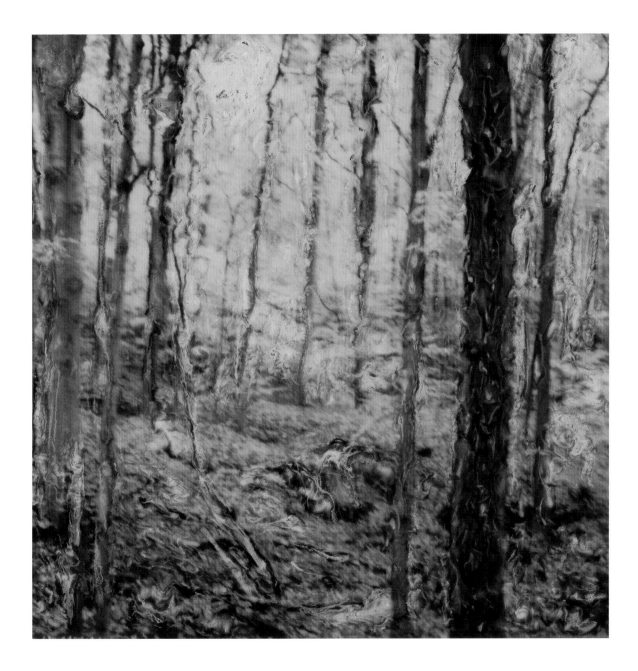

From Above

If you were
a hawk soaring
in the air
above trees
whose leaves
are changing

what would you
say about how
a view from
above affects
the color & shape
of what you see?

 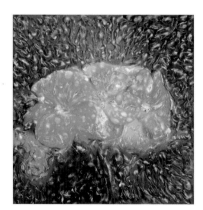

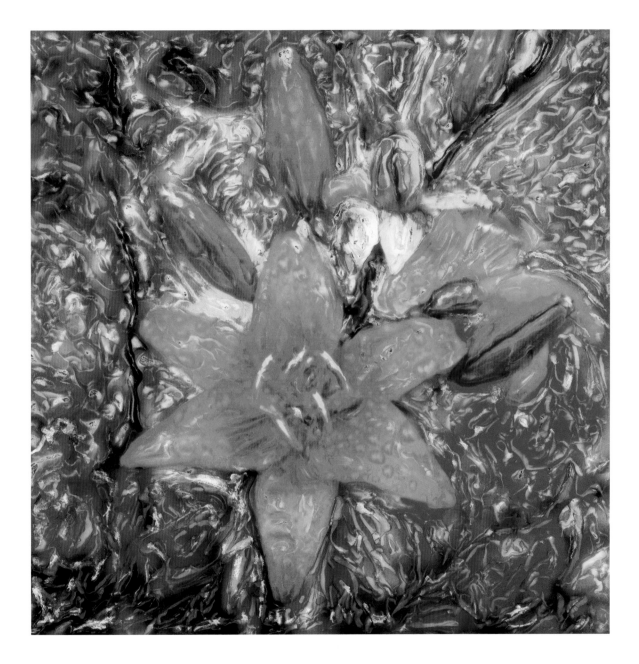

Deaton's Woods

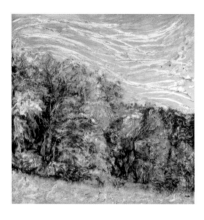

Beyond a sloping line of trees
that curves at the bottom of a hill
stretched Deaton's Woods. I never

entered those magical woods
without hearing squirrels
drop cuttings from the tallest

shagbark hickory I have ever seen.
Somebody shot Martin Luther King,
but the squirrels kept coming back

to the tree that towered above others.
Somebody shot Bobby Kennedy,
but the squirrels refused to abandon

the shagbark so laden with fruit.
Our cities went up in black smoke,
my love life went up in flames,

& my academic career almost
went up the creek, but those wise
squirrels kept returning to their tree.

Reader, come back with me
to Deaton's Woods, to sit under
that tree I have kept to myself.

We'll share the patter of cuttings,
look for the flicker of a tail,
& watch the branches bend.

No matter what kind of tragedy
rips at the fabric of our nation,
even if police club students

in the streets & politicians
attack one another on the networks,
we'll behold squirrels in that tree

that stands somewhere in the blue
haze of Deaton's Woods beyond
the tree line that slopes & curves.

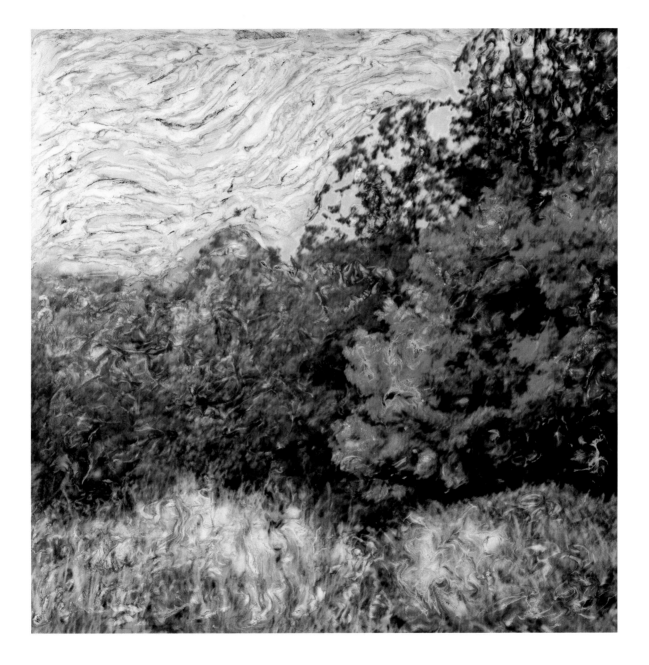

Woods Meditation

I am a mind
meditating
in the middle
of these woods

& my spirit
is squirming
to break out
of its cocoon

& flutter up
into the sunlight
above the body
it leaves behind.

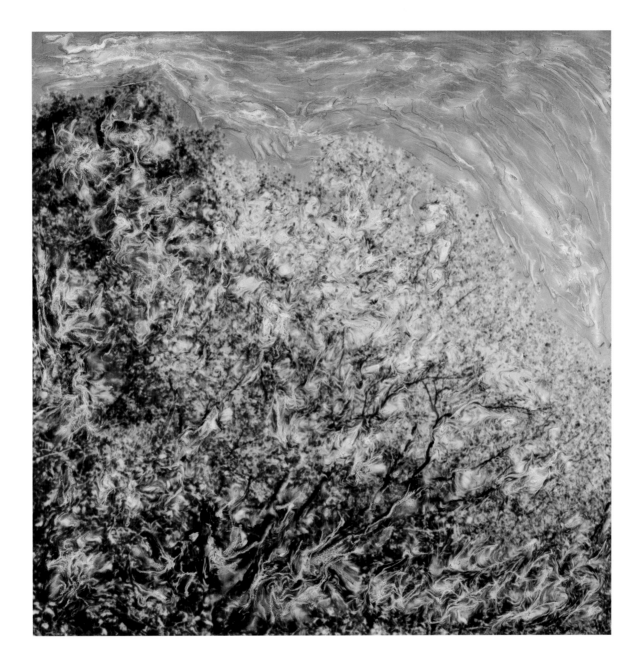

A Few Dry Leaves

A few dry leaves
on a slender branch,

white air
turns to frost

as light oozes
from beyond,

& the silence
of a universe

curls into
itself as

everything but
a few leaves

about to fall
is already gone.

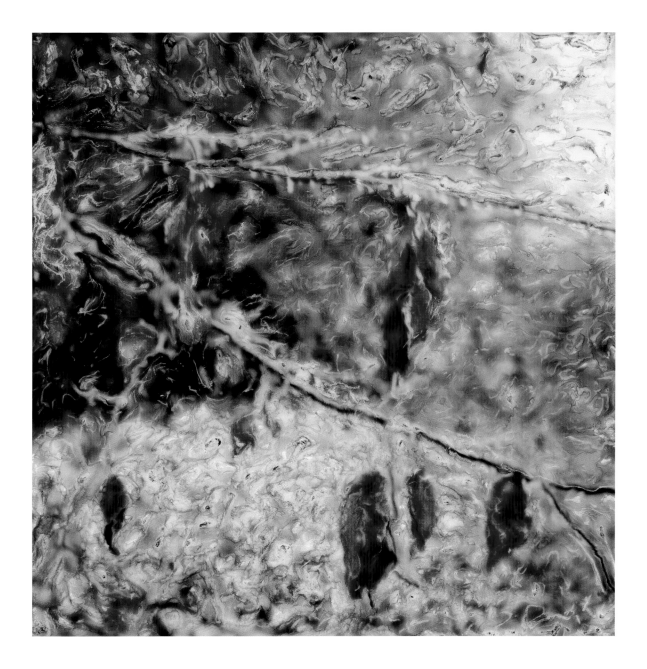

Tree Vision

It can take a tree
with its branches

all dead and gray
to make you realize

what the colorful leaves
on a living one say.

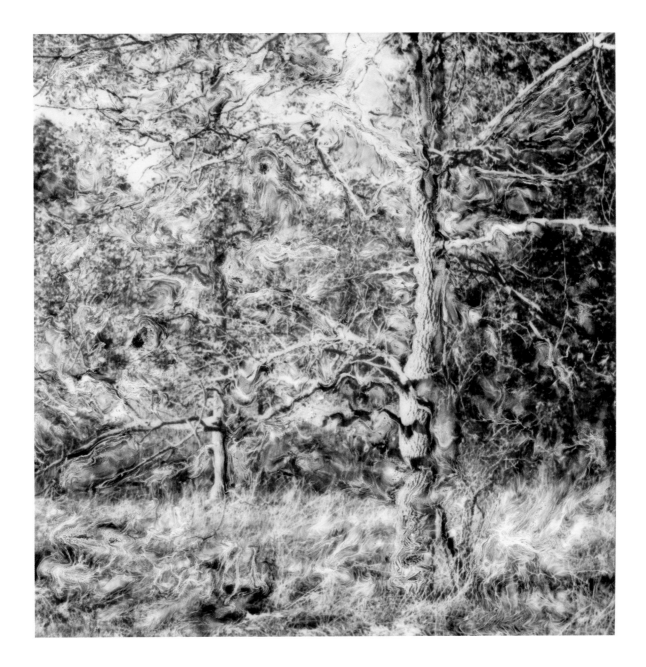

Faith

Sometimes the way
winter trees stand
bereft of leaves

tells a story
of lines merging
and movement begun

we could not
see if green
leaves intervened.

The steady eye
of another
beholder can

bring into focus
two shadowy boles
rising from one trunk

arching away
from one another
but apparently

about to touch
at some point
beyond which

our eyes cannot go,
but real enough
for us to believe in.

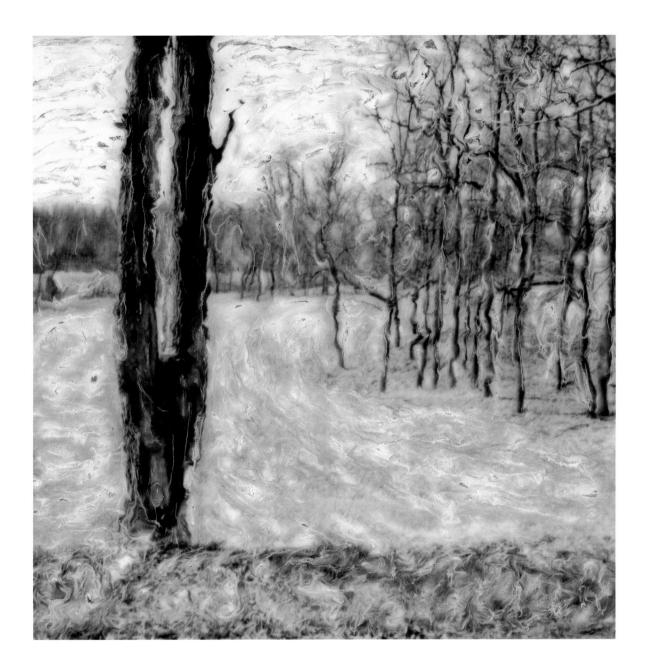

Winter Tree

If you were
a winter tree

your branches,
lightened of leaves,

would reach toward
the blue beyond,

while your twigs
sensed that when

light increases, buds
will swell & open,

green leaves
unfurl, & shade

find the right
place to curl

on the ground
where your

roots have
gripped down.

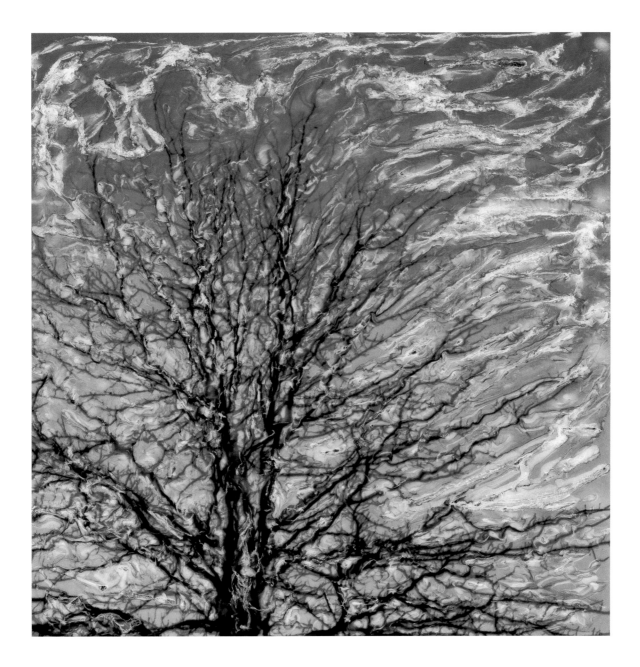

David Ignatow's Trees

My New York Jewish friend
saw the trees as tall gods
commanding a view
of his Long Island study

& bent over his typewriter
to compose ceremonies
for the gods
in plain-spoken poems.

The sound of his urban
American voice rising,
in prayer, in my ears,

I look out my study window
at trees in the heart of the interior,
to which I have returned,
bow my head at my desk,

& compose this Indiana
German prayer of thanksgiving
for his friendship,
the power of his words,
& the gifts of our gods.

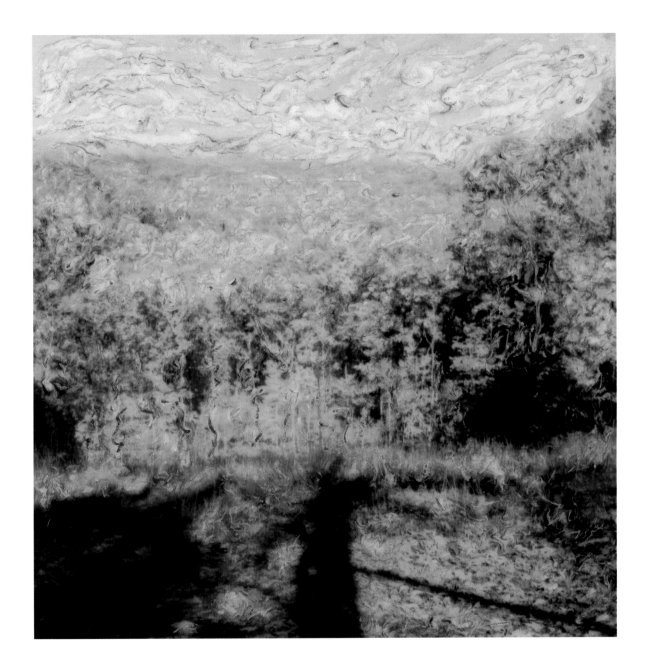

Bare Tree Song

Give me a tree,
bare of all leaves,
standing in a field.
Let snow fall
on its branches.
Let darkness settle
upon the scene.
Animals step out
of the woods
& sit around it
in a circle
moonlight finds.

Now close your eyes
& let the tree
& the snow
& the animals
& the moonlight
enter inside you.

What do you see?
What do you hear?
What do you feel?

Open your eyes.
Now sing your song.

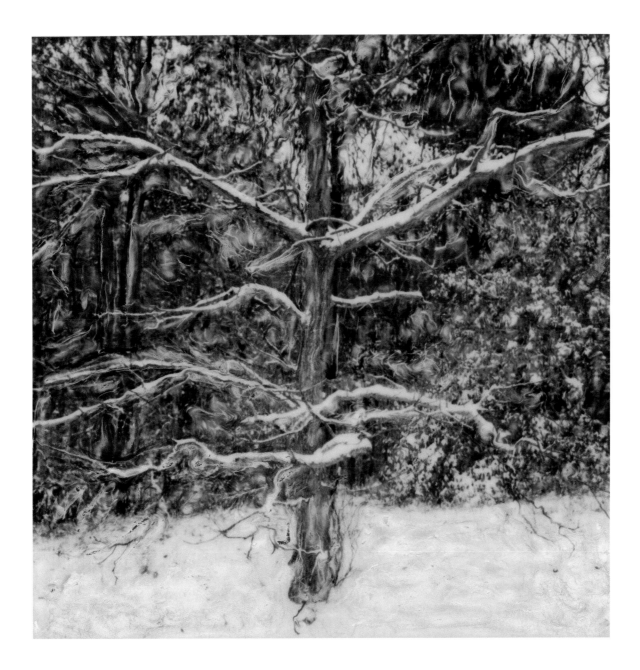

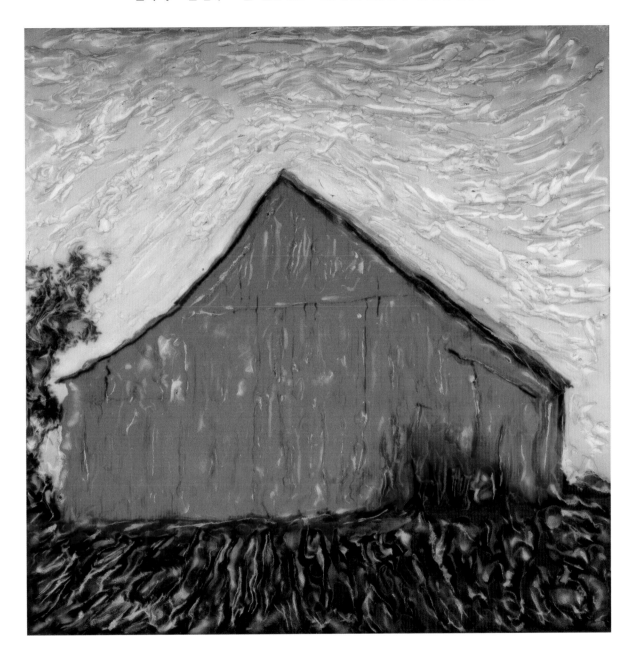

Pump

Something about a pump handle
appeals to a bare hand. When you

push down, compression starts to build,
water rises through the dark, toward you,

from the depths, bursts through
the pipe, & pours into a tin ladle.

When you lift & sip, earth-cold
water anoints your warm lips.

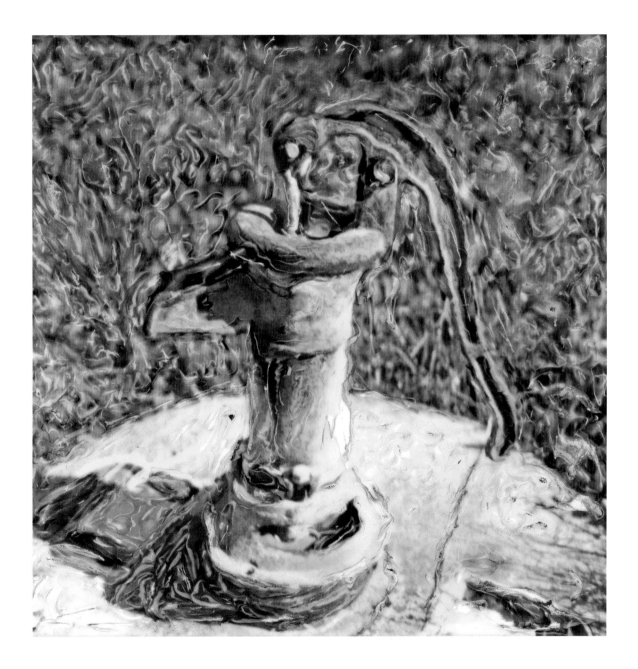

Tale of the Red Barn

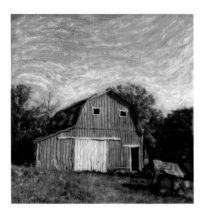

There once was a red barn
with tin roof & white doors.

It was a place to romp & hide
for boys, sanctuary for cats,
hostel to those who stand
on fours & chew what
grows in the fields.

It was a drum for hard rain
& hail, venue for fiddling
& dancing on Saturday night,
house of worship whenever
a calf or colt was born.

Up in the dark gallery
sat rows of bales that
could erupt into flame
if they came in early,
wet behind the ears.

Every night this red barn
with tin roof & white doors,
a ship with a cargo of animals
exhaling warm breath, sailed
off somewhere into the dark,

& every morning we found it
moored back at the dock when
we came to milk the cows.

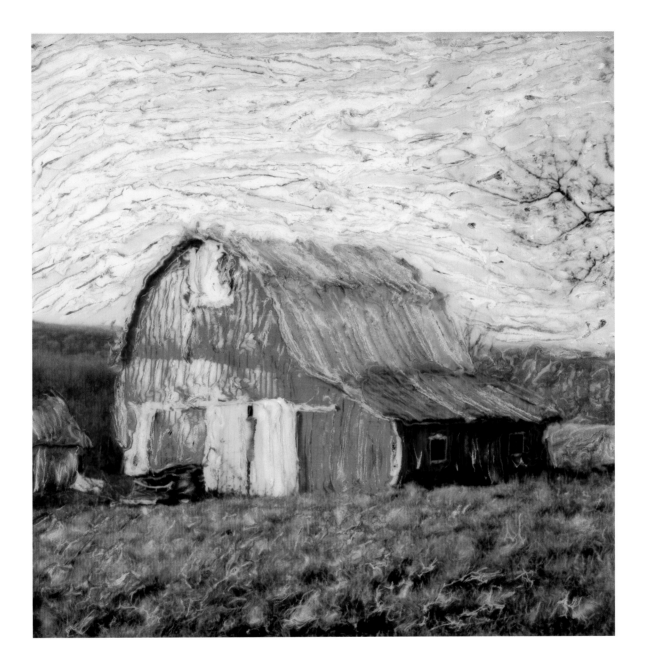

IN THE BARNYARD • PAGE 111

Midwestern Scene

In front of
a small barn
& short silo

stands a windmill.
What modest breath
makes the wheel turn?

Who dabbed
dusty clouds
in blue sky?

Slanted rays
of light
onto the silo?

Kept everything
in scale so that
all elements of this

quiet scene speak
in harmony with
simple elegance?

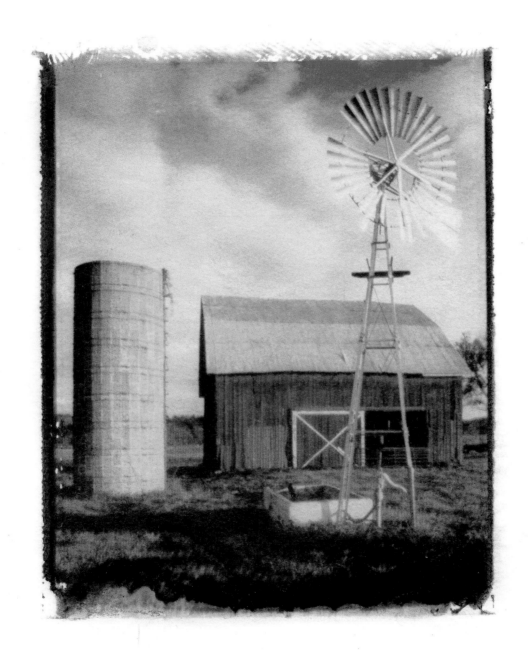

Leaning Barn

When a barn
leans to one side

do we walk by
leaning to the other

in the hope
of making it

stand straight
again before

we go down
into the earth

that supports it?

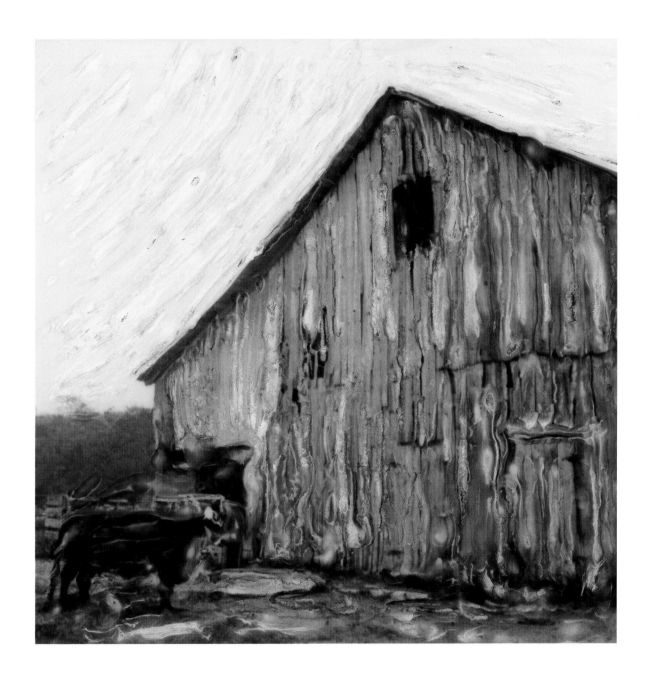

Barn Secrets

There is a barn
with a prow & a tower
& an open door

& on certain nights
the secrets of the farmers
come out of the barn

into the yard
& cavort like elves
in gowns in the light

of the moon.
Toward dawn
the secrets slip

out of their gowns
& through the door,
roll up in the hay

& doze through
the day until
the moon appears.

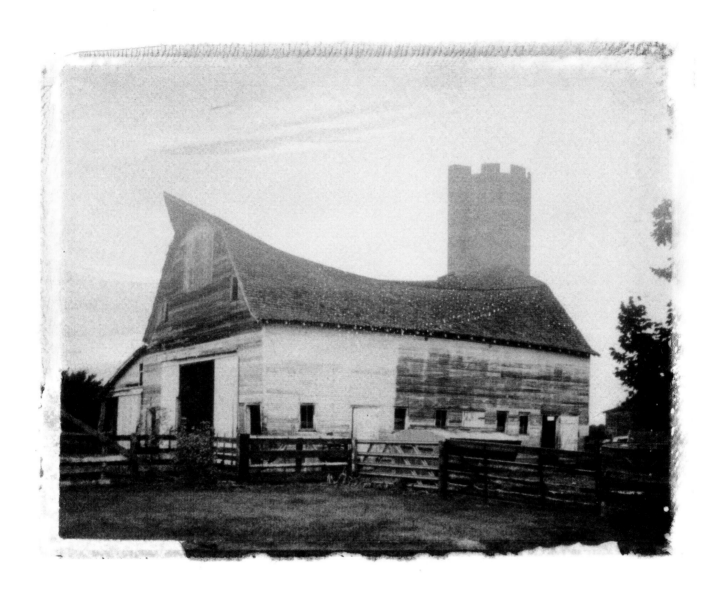

Red Tractor

Crawl up on a red tractor
& people see you as different
when you get to the driver's seat.

Crank her up & feel hot exhaust
belch & billow into the sky.

Push the hand clutch in
& feel her lurch ahead.

Grab the knob attached
to the wheel & spin it
around so the little wheels
in the front cut really short.

Crawl up on a red tractor,
steer it between bales
of hay with a wagon
following behind

& you're the main man,
the big cheese who never
wants to come down.

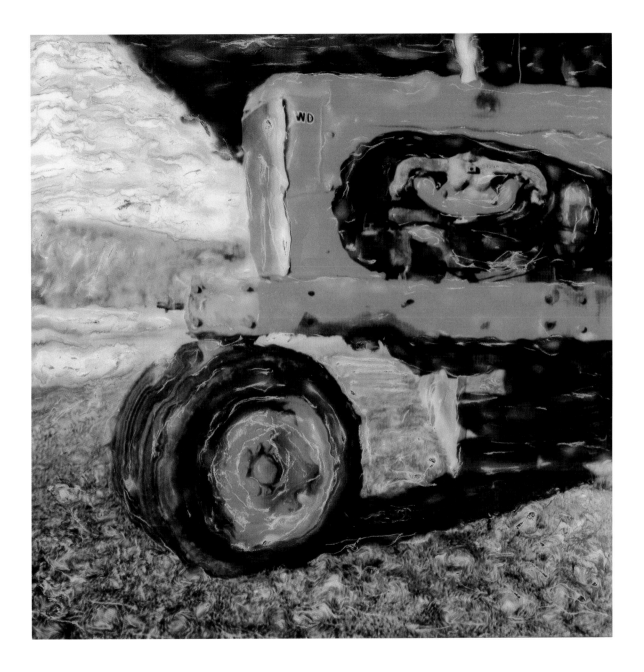

Barnyard Moral

Let a red barn
with a tin roof
soar up into blue sky

until we awaken,
& it settles back down
as we grow up.

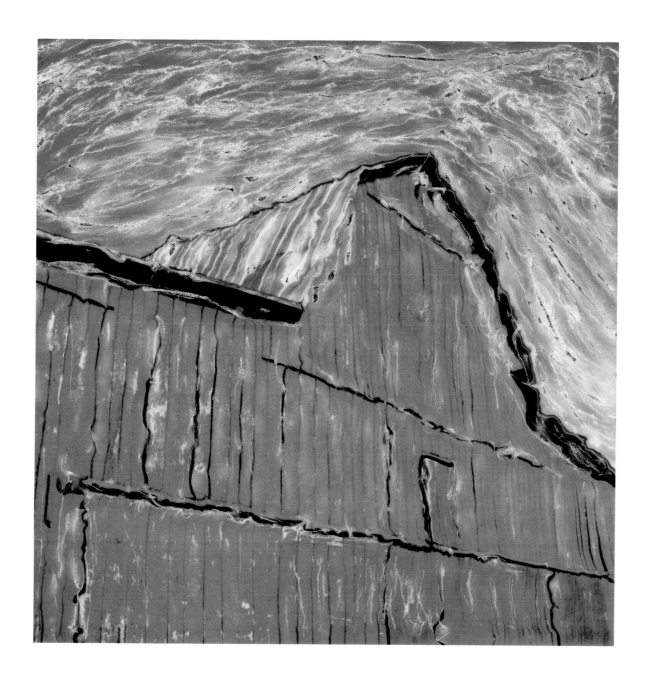

Boy on Horse

When a boy
rides a horse,
the saddle

lifts him up,
the stirrups push
against the soles

of his feet,
the reins transfer
power to his hands,

he moves on
a higher level,
& he can see

faraway presences
that until now
have been invisible.

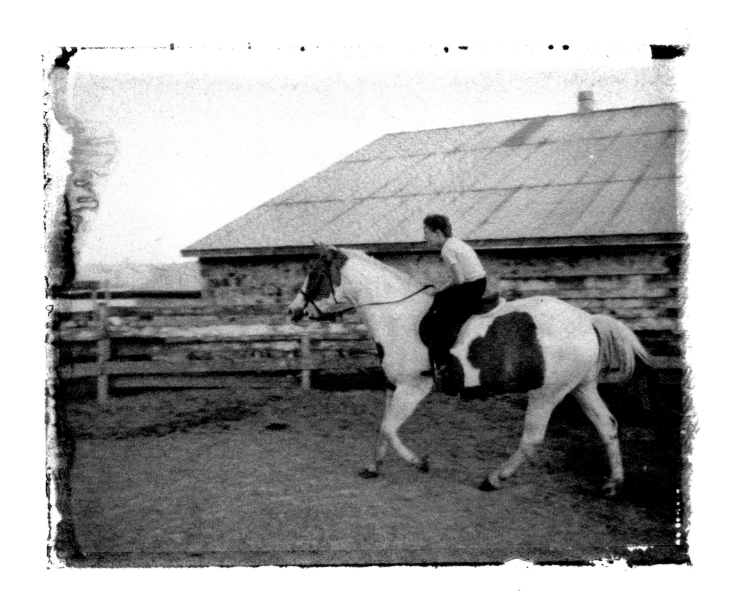

Two Kittens

Two kittens, balanced
on a wooden ledge,
look in the same direction,

poised for any action
that may come their way.
They both look at

the same thing,
however large,
however small,

down at shoe level,
where the mysterious
always seems to gather.

They are ready
to go to it, if it will
not come to them;

but what they like best
is staying put where
they can look down

at shoe level
where the action
always begins.

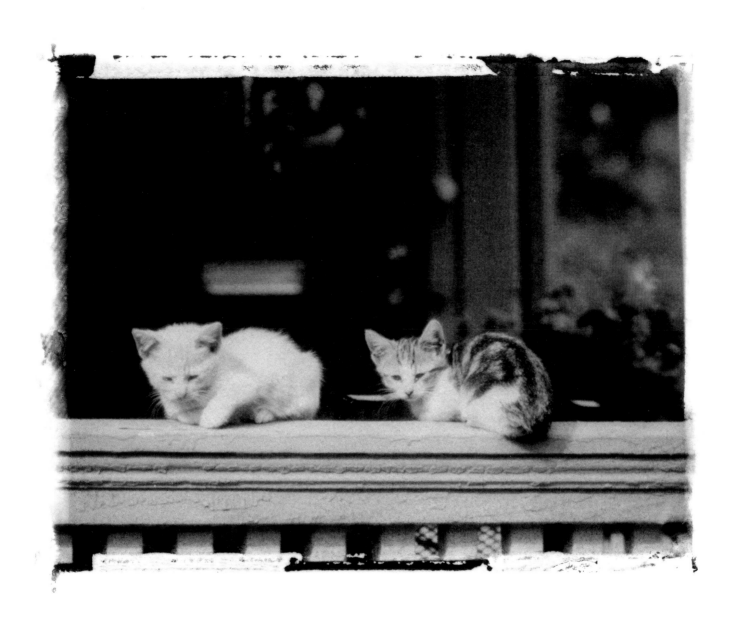

In an Eye

In the eye
of a dog

shines the light
of a wolf.

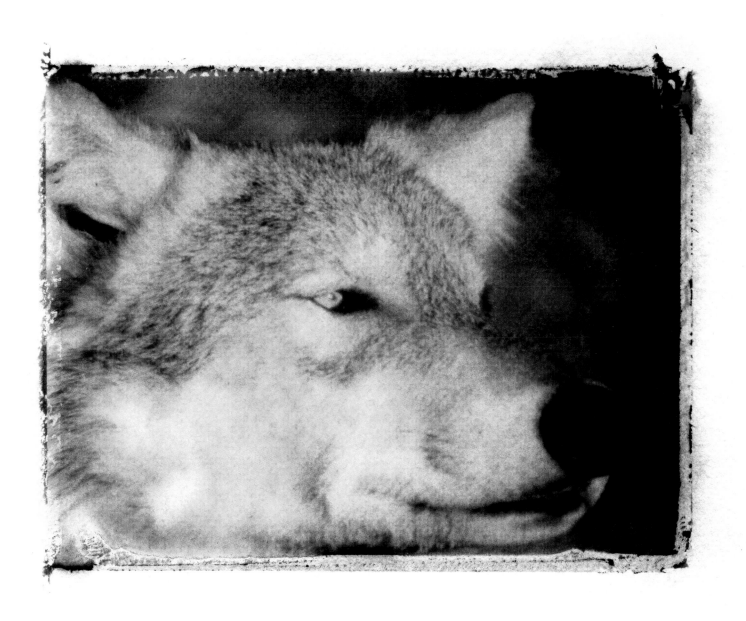

Cattle Stare Down

Sometimes the way
cattle turn & stare

makes you want
to excuse yourself

& crawl back
into a hole

you dug when
you lost it all

& spoke in the wrong
kind of language

to reach the creatures
who share your world.

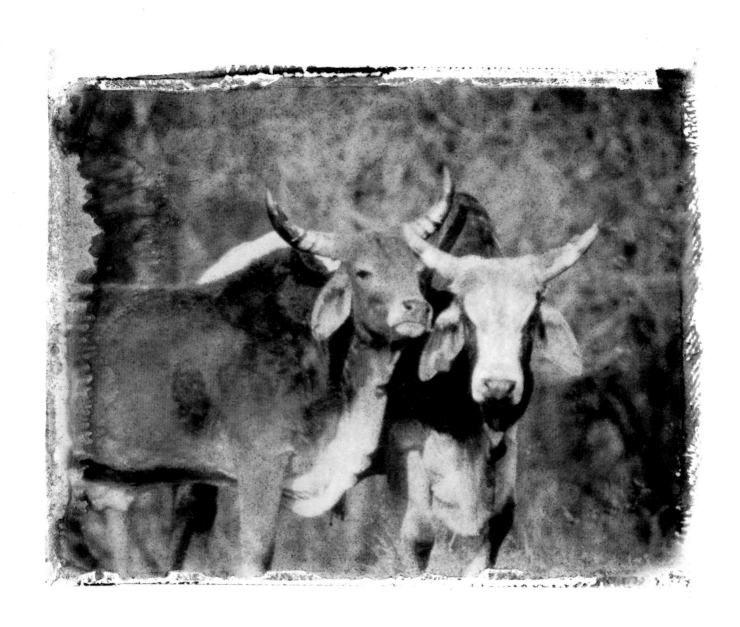

American Dream

If I owned a farm, I'd build
not one, but two, silos. One
would hold regular silage
for ordinary cows, but the other

would be packed with a high-proof
formula. Only the best cows would
be allowed to chew the hopped-up
variety, when I choose to dispense it.

The bull would have to keep
his distance, but a few steers
might be allowed to share
the good stuff, for balance.

Word would get out around the area
about the special ingredients
in Silo Number Two, & my
neighbors' cows would not be able

to stop jumping all those white fences
so they could dine in my barnyard.
The full moon would find countless
cattle lowing to be let into my red barn.

Every morning when I pulled up a stool
& looked into big brown eyes, udders
would be swollen in gratitude & every
teat ready to spurt milk & honey.

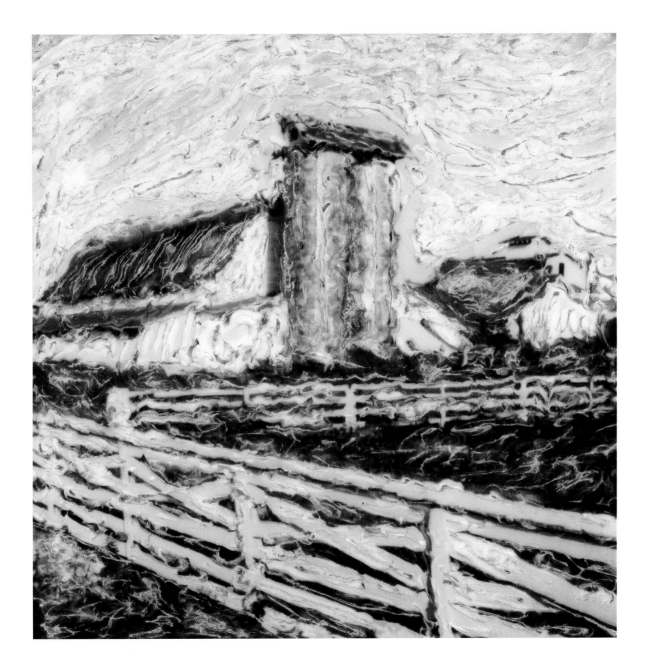

IN THE BARNYARD • PAGE 131

Circles & Lines

Circles have been known
to run around together,
get tired, & lean up against

board and batten for rest.
When this happens, the sun
brands hot black shadows

across illuminated boards,
a door opens, & we yearn
to crawl into the cool interior.

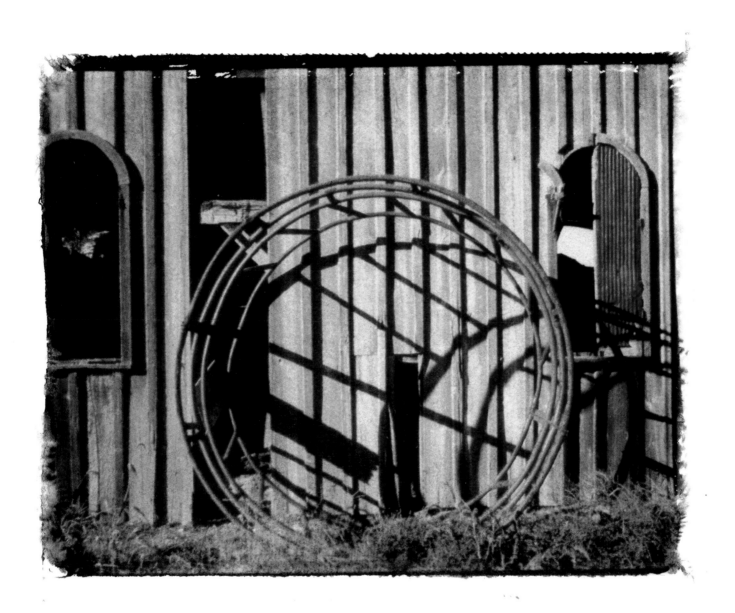

Freudian Quiz

Sometimes a cigar
is just a cigar
& a hose
is just a hose

but if you wanted
to water the flowers
because they are dry
or cool yourself down
because you are scorched

which would you use,
a cigar or a hose?
And if you're one of those,
please tell us why
& what you imply.

The New Kingdom

With the night-blue sky at my unbending back
& the full moon illuminating the fields

I am going to step out of this barn-loft door
onto that roof below and proclaim the New Word

to everyone in the fields and the woods below,
my enemies be damned; my friends the animals have

the good sense to listen and follow wherever I lead
and we shall set up the new kingdom of Polaroids

& Poetry as our eyes and ears decree, at the right spot,
at the right time, and all who follow the Holy Writ

as we set it down shall be saved & see into the past
& the future & establish peace & harmony & those

that don't will be condemned to squint forever at repeats
of TV reruns on boxes that flicker with pale images.

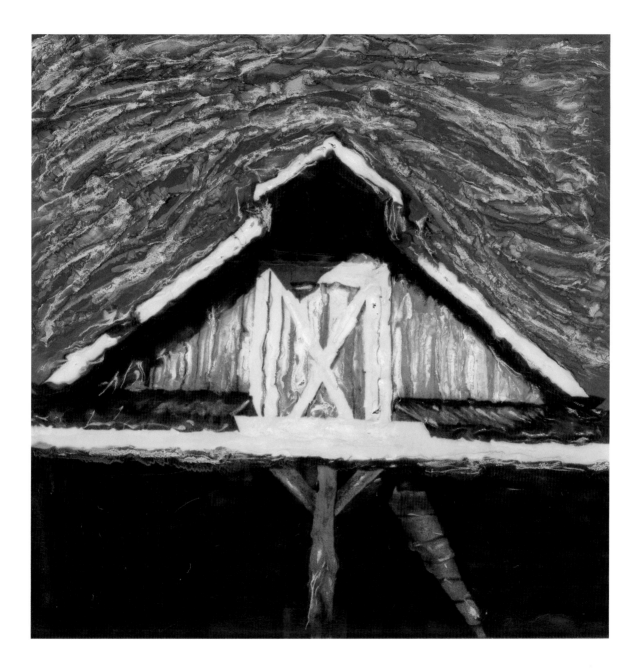

A Red Barn for the Joads

We could allow the ghostly Okies
wandering in the rain to discover
this dry barn. Their jalopy truck
sputtered & died on the road again.

The Joads, who lost their farm
to the banks and Grandpa
& Grandma to the road, could
stagger in by the side door.

If they happen to find
a young boy whose emaciated
father lies dying on the floor,
Ma, who rises to every occasion,
could take charge & speak fiery
words again. Pa could stand & stare
while firebrand brother Tom is off
fighting for a scrap of dignity.

Rose of Sharon, who just lost
her first baby, could give
the old man her breast, under
a blanket. The animals would
all understand, but some people
might not. Worse things happened
in our families during the Depression.
Lots worse could happen in red
barns all over southern Indiana.

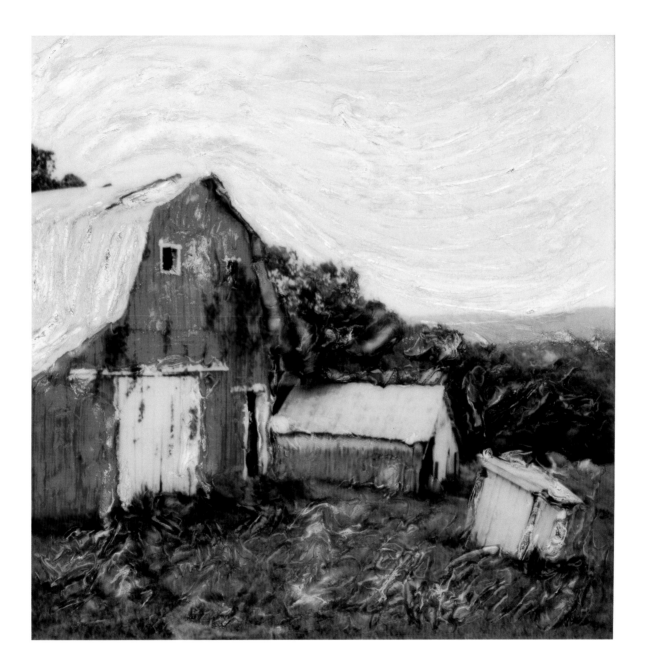

What's in Wood?

What do you see & smell & feel
when you touch the hand-hewn
beams that have remained parallel

to the ground in this old structure
for so many years? How many rings
were there in the tree that was once

upon a time felled by the people
who built this shelter to keep rain
out & grain or animals in? What

will be lost when this small building
is allowed to tilt & collapse & crumble
into the ground? Will the woods remember

the spot where the tree once stood before
human hands brought it down? When
these hand-hewn beams have rotted

& gone back into earth, will any
descendants of the builders of this shelter
know what went on inside it and pass on

the story to those who will live
in the house in the development
that will surround & replace it?

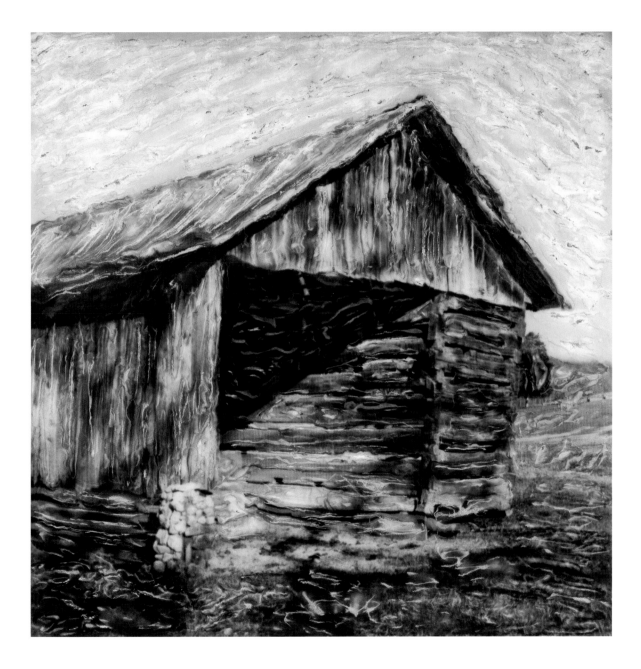

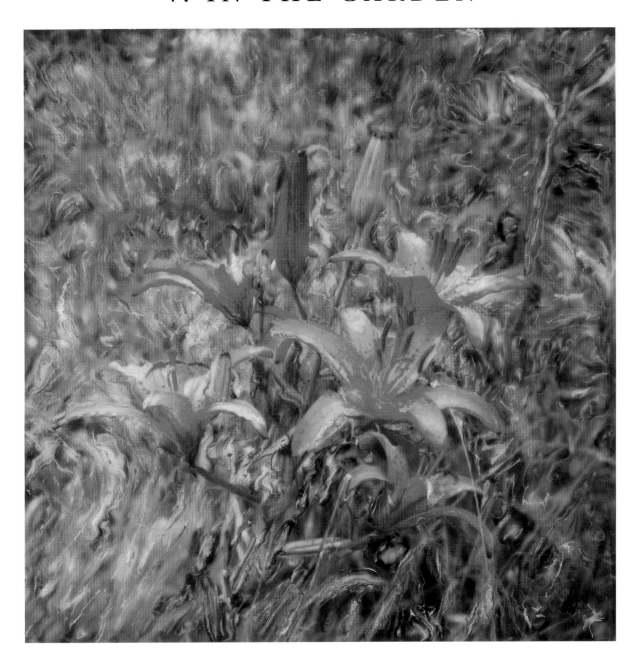

Over the Footbridge

Come with me across
the sunlit footbridge.

We'll walk into shadows
where the air is cool.

Let's enter the darkness
as if returning to the womb.

When we come back out,
we'll have new eyes that see

in both sunshine & shade.
We'll be like Adam & Eve

& survive better in the light
because we've been in the dark.

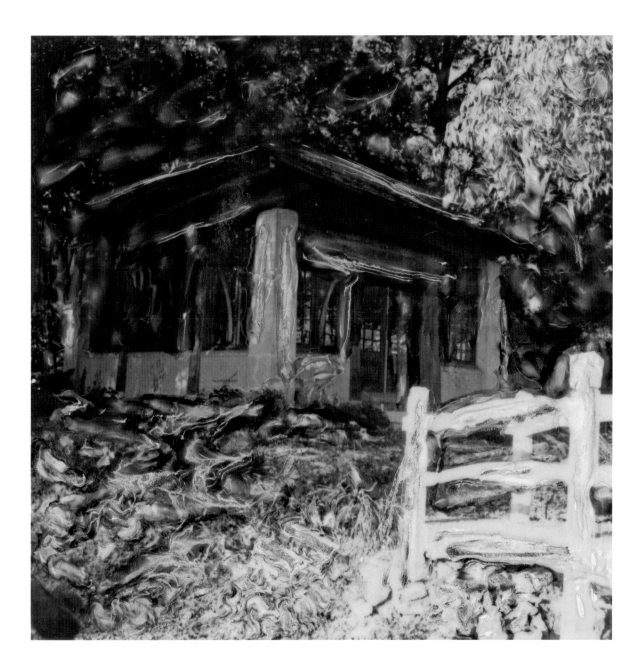

I Remember When

I remember when
the flowers bloomed
in maroon & white

not far from my hands
& there was gold dust
at the center of every

single blossom & bees
buzzed through the day
until they went back home

& fireflies took over
at dusk & blinked
their little lanterns

like circus performers
just above the tips
of blades of grass

that pushed against
the soles of my bare feet
& tickled my toes.

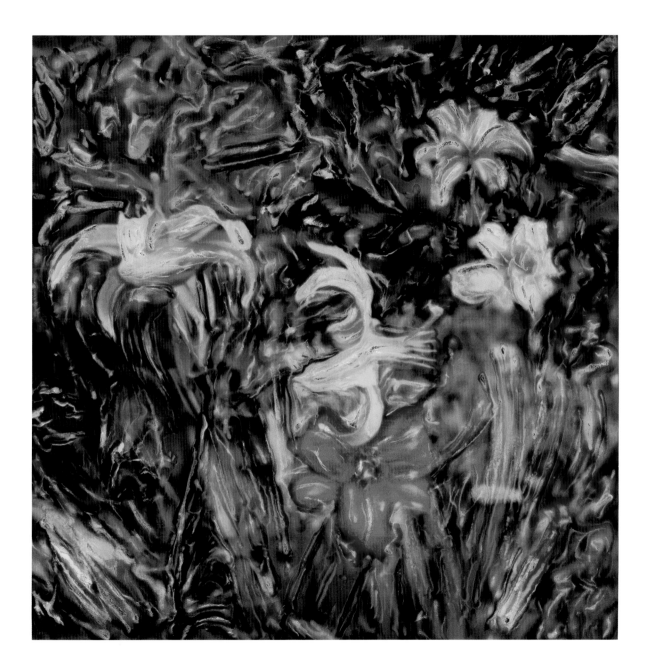

Baby Bird Flowers

Sometimes flowers
are like baby birds

that open their mouths
& what you see

is a shade of bright color
around the fringes of feathers

& what you hear
is a quiet cheep-cheep

begging you to feed them
a morsel of attention

you must give them
only with your eyes.

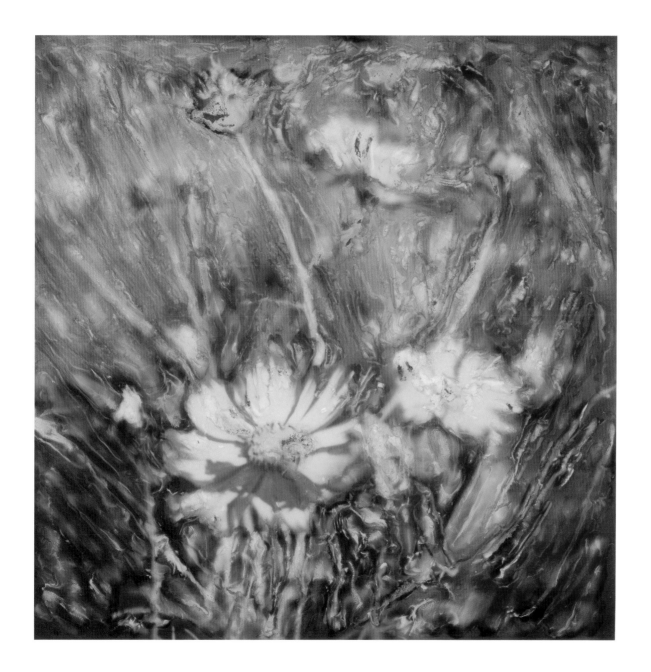

Georgia O'Keeffe's Flowers

Whenever I look at a day lily
bursting with color, I recall
that when Georgia O'Keeffe
painted lilies, irises, poppies,
she made them larger than life.

People do not take the time
to look, she said, *and so I made*
flowers so big even New Yorkers
would stop and look at them.

Each flower became a country
with its own topography, contours,
corridors, & borders of deep color;

you want to wander endlessly
in its wonders, touch & taste
its textures with your eyes,
turn each petal on your tongue,

& as your senses are deepened,
beauty tingles in your fingertips.

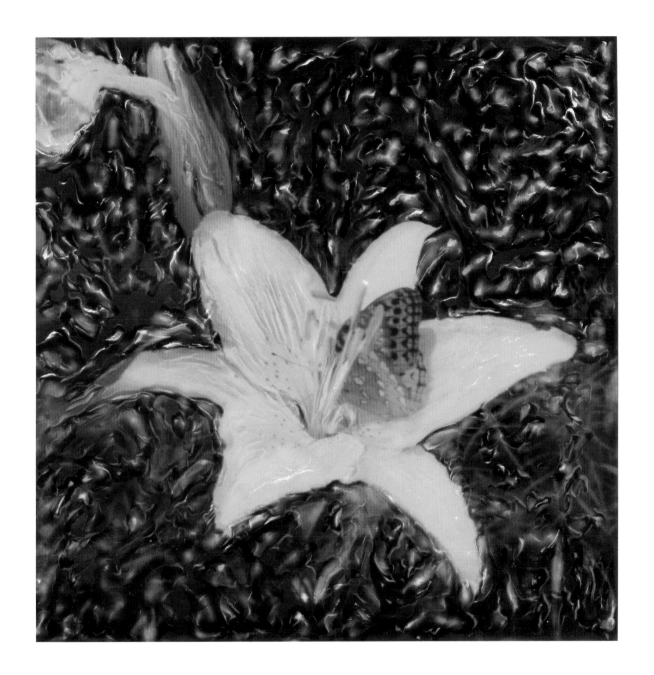

Blake's Vision

If Blake beheld eternity
in a grain of sand

what did he see
in the heart of a flower?

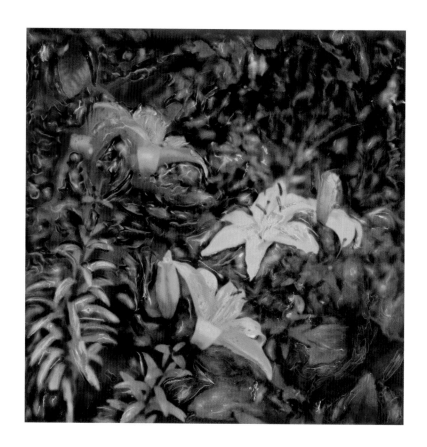

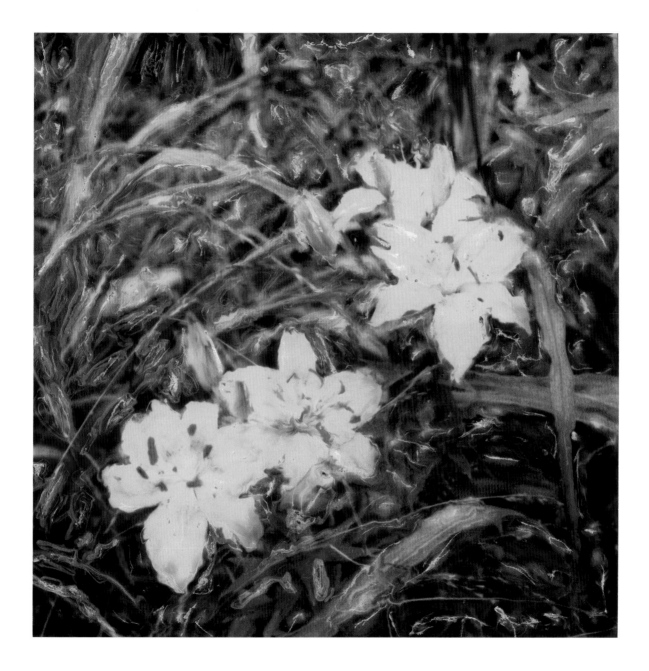

Close Look

The closer we look
at what we love

the more darkness
becomes visible

in the heart
of what we see.

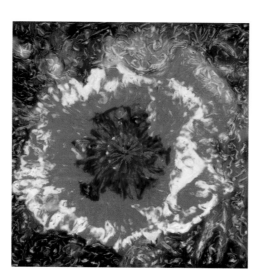 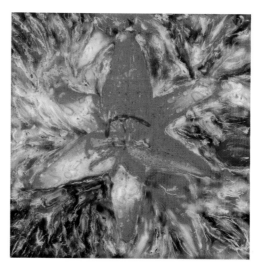

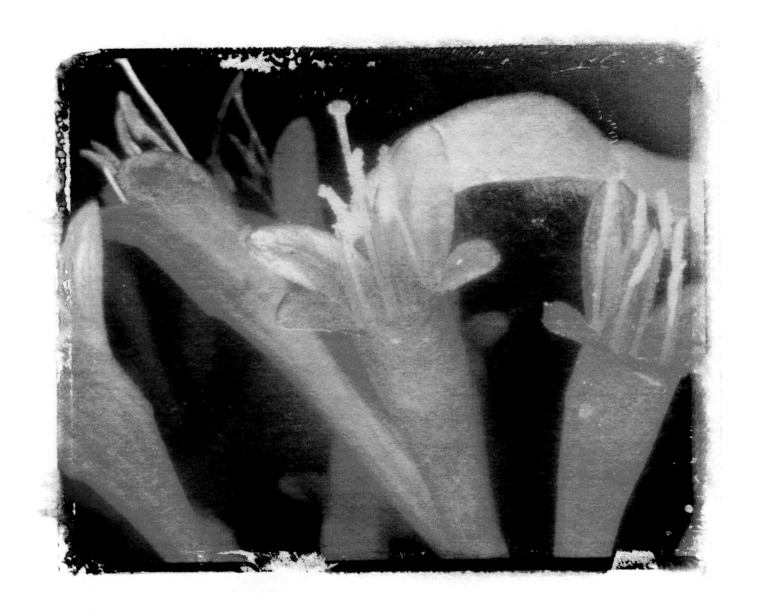

Siamese Eyes

Whose Siamese cat
with such piercing eyes
& stiff pointed ears
looks up at me

as I look down at him
standing between twigs
& dried flower stalks?

What does he see
in me as I try
to extract the essence
of him to give to you

and who and what
lives behind these
two blue irises
& dark pupils?

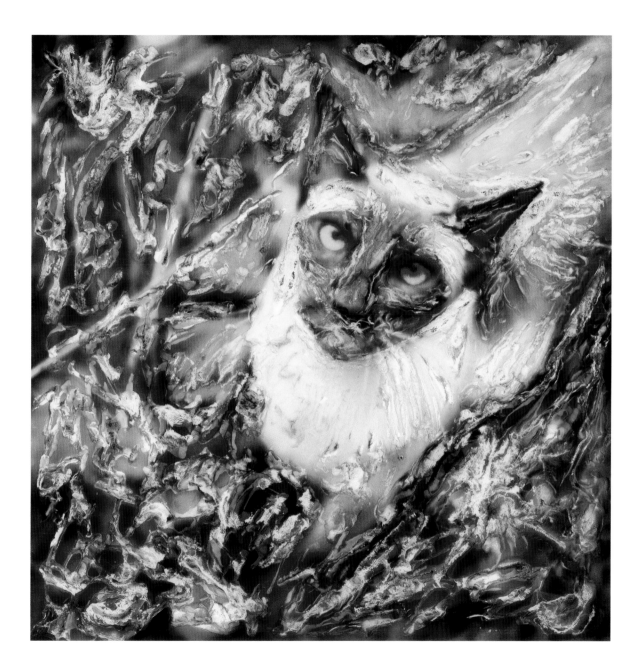

In Defense of the Zinnia

Zinnias do not
beat around the bush.

They come on straight & strong:
crimson, orange, hot pink, fuchsia.

The leaves come right to a point
& are a hale & hearty green.

If you like a delicacy
of flavor, nuances of color,

an understated voice of expression,
the zinnia is not your companion.

If, on the other hand,
you like a bold declaration

& a wakeup of color
in your daily life,

put them next to your door.
They will remind you not

to go gently into the night
or to sleep through the day.

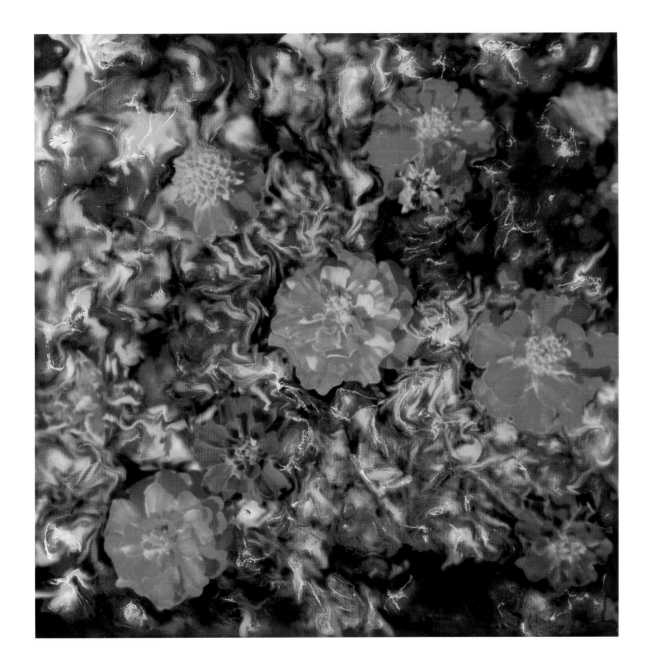

Emily Dickinson's Inebriation

If Emily Dickinson
was the inebriate of air
& debauchee of dew
who entered the foxglove's door
& reeled into inns of molten blue

I am the devotee of fiery
red & sunburst yellow petals
who loses his balance
kneeling to sniff
the intoxicating essence
gathered at the center
of the folds of this flower,

is blinded by the light
of tiny stars beaming
at the intersections
of such bright color,

& falls head over heels
in love with the magnitude
of beauty concentrated
so gracefully in the creation
of a thing so small.

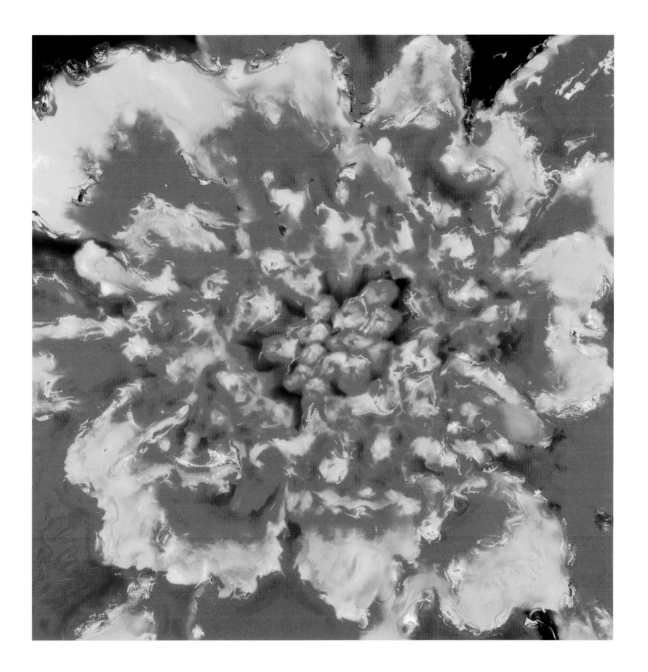

Anne Bradstreet's Garden

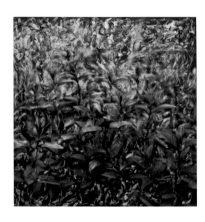

When Anne Bradstreet, child
of England, contemplated a mighty
oak in the New England forest,

she concluded that eternity must
scorn the age of such mortal
majesty, & she turned her ear

to the song of the cricket & grasshopper
at her feet. She found herself as poet
not worthy of the bay laurel prized

by the Greeks, but felt she deserved
to wear as prize what she cultivated
near her cabin door: parsley & thyme.

Reader, let us honor Anne's wisdom
in reaping the images she sowed
& cultivated in her garden & for

prizing the music she heard at her feet.
May we listen for the song that rises
from what grows in the garden we tend.

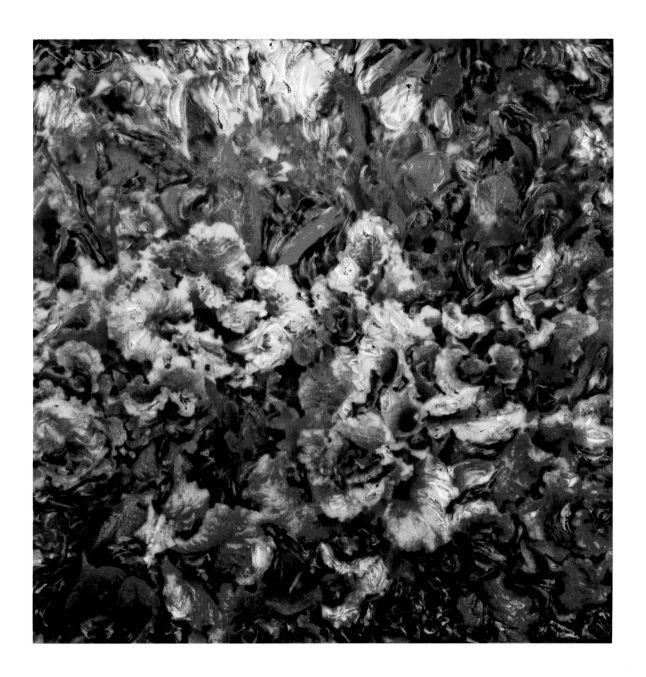

Flower Interior

Even when we see
inside the heart
of a flower

& study the parts
to which we can
give the right name

we still have not
touched the mystery
of how it works.

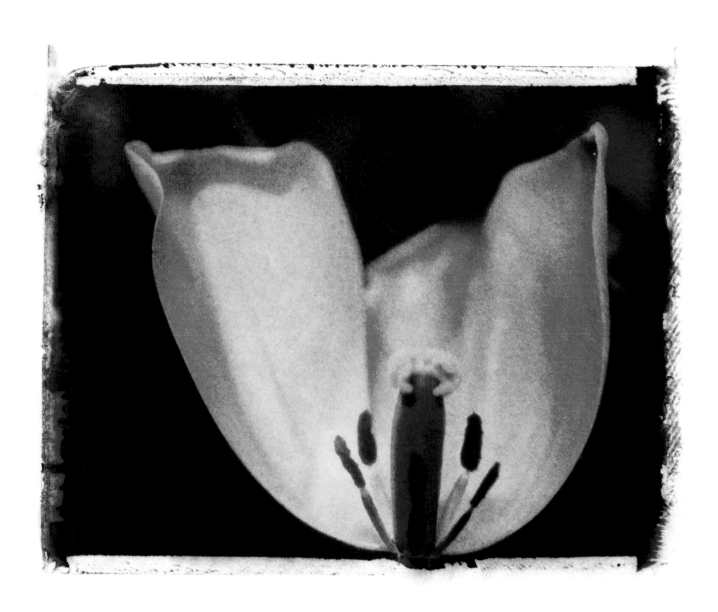

Emerson's Rhodora

When Emerson found
the wild azalea
blooming in a dreary

spot in the woods,
he concluded that
beauty is its own

excuse for being,
but why should
a flower need

any excuse to
open its folds
of perfection,

no matter where
it grows, except
to praise the hand

that touched it
to life, even if
no eyes behold.

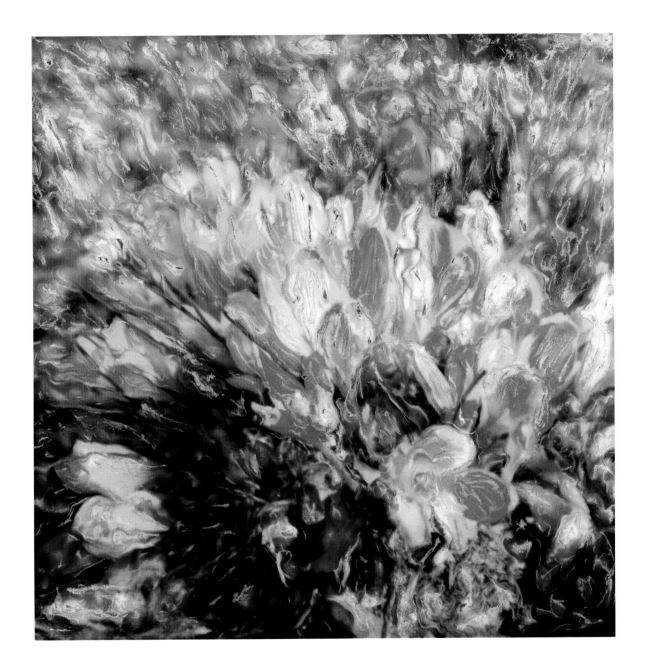

The Angle

The angle at which
the eye sees
the stalk which
bears the bloom

determines how
we perceive
the colors
& texture

of the petals
that stage
the play
of light & dark.

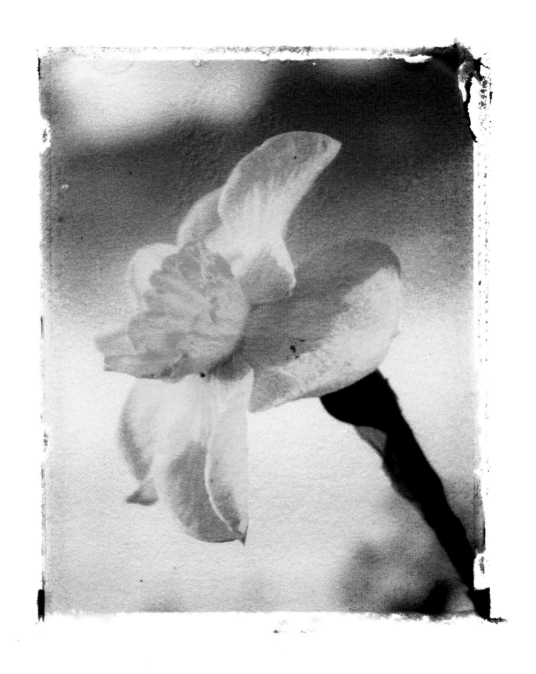

Robert Frost's Heal-all

One morning Robert Frost found
a freak albino spider holding
a white moth near a white flower
that is supposed to be a healing blue

& he wondered if there could be
a design in the universe calculated
to appall. When we see white
crocuses after their burst of glory

& promise of rebirth, what do
we conclude when they decline
& bend to the ground? Do we

concede that they merge with the earth
& nourish what will later emerge,
or do we allow our spirits to droop?

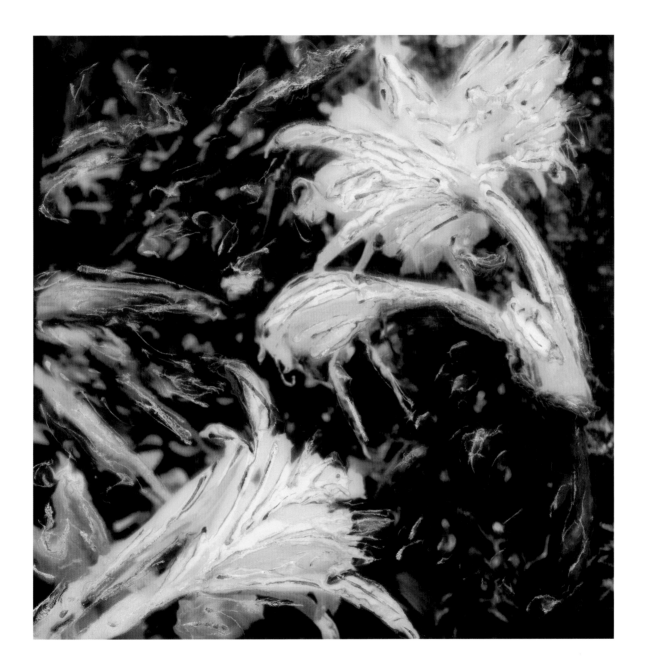

Dark Blue

Blue, dark blue petals
with a little light splashing
on them from the west,

growing darker & darker
as the sunlight fades,
calling us to come along

into the night,
toward the unseen,
into the unknown.

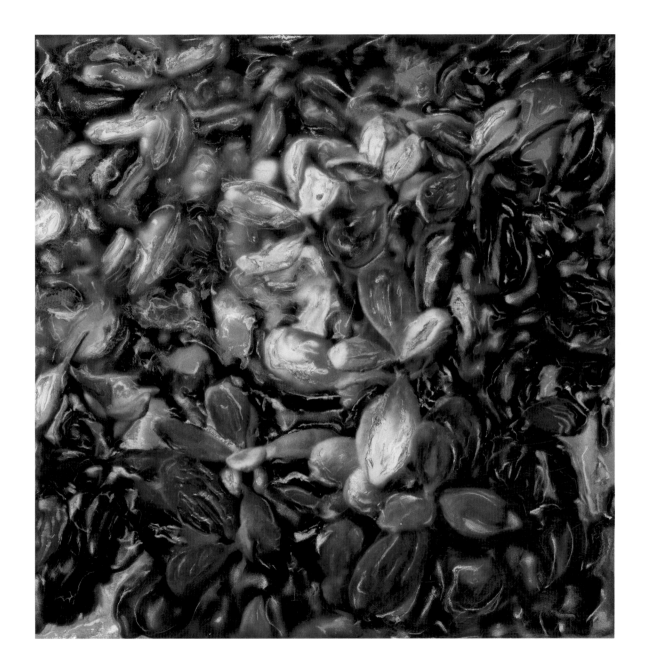

Rilke's Shadows

When Rainer Maria Rilke
prayed for a good autumn,
he asked God to lay His
shadows on the sundial.

When we take a walk
on a day of sunshine
that lays shadows
in beautiful patterns,

should we keep our feet
in sunshine, let them touch
the shadows, or just close
our eyes & let them fall?

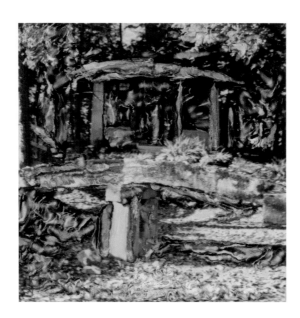

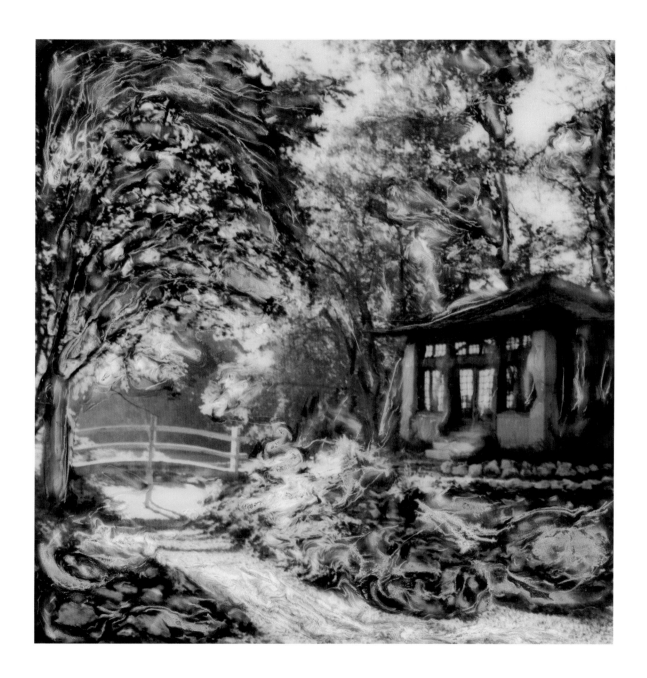

Low to the Ground

Often the burst
of the flower
flashes in the eye,

but after the blossoms
fall to the ground
our eyes adjust to

the nondescript
swirl of green
that declares its

pattern slowly,
low to the ground,
before it, too,

sinks into
the darkness
of winter.

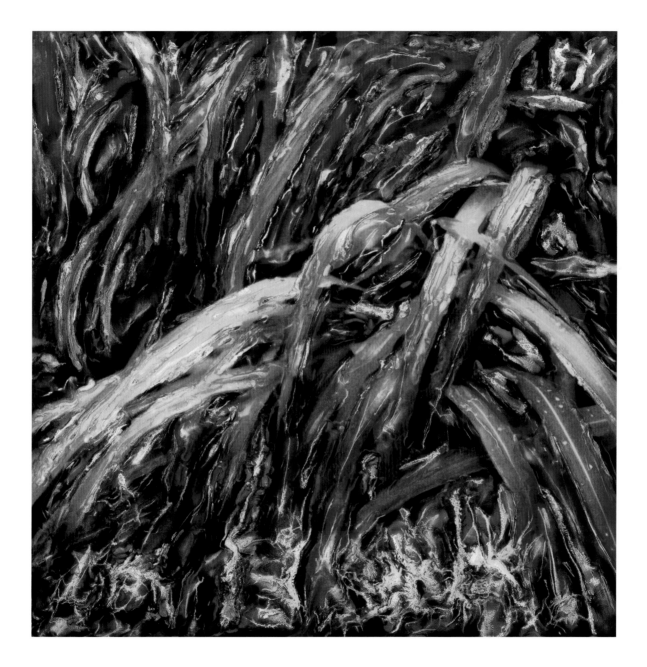

Army of Orange

We've had it, we're fed up,
get out of our way, we have
joined forces. Today the patch,
tomorrow the whole wide world!
We are the Army of Orange.

No more pies on Turkey Day!
No more soups with nutmeg
and butter. Keep your nasty
knife to yourself, stop cutting
out those toothy grins
& stupid triangular eyes!
Never again will you dare
to roast & salt our seeds
or stick a burning candle
in the middle of our belly.

If you think you can keep on
slinging our slimy guts
into the garbage, Mr. and Mrs.
Homebody, why don't you just
pucker up and give our bottoms
one great big resounding smack?

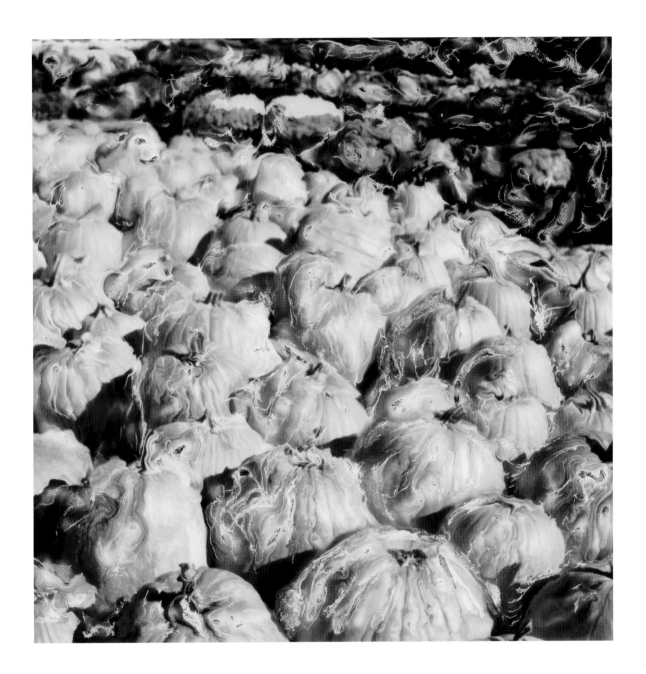

Cockscombs & Mums

Where feathery cockscombs stand,
their cousins in color the mums
should also be given a bed & a chance
to speak in burnt sienna, wine red,

lavender, yellow, & snowy white,
near rows of purple cabbages,
& tell a tale of leaves falling
& crisper air, sunlight

a different slant, wood
smoke rising in chimneys
at night, & a slow winding
down of rhythm that makes

us turn inside the house & look
back out the window to see
how long the sienna will burn
before the first flakes fall.

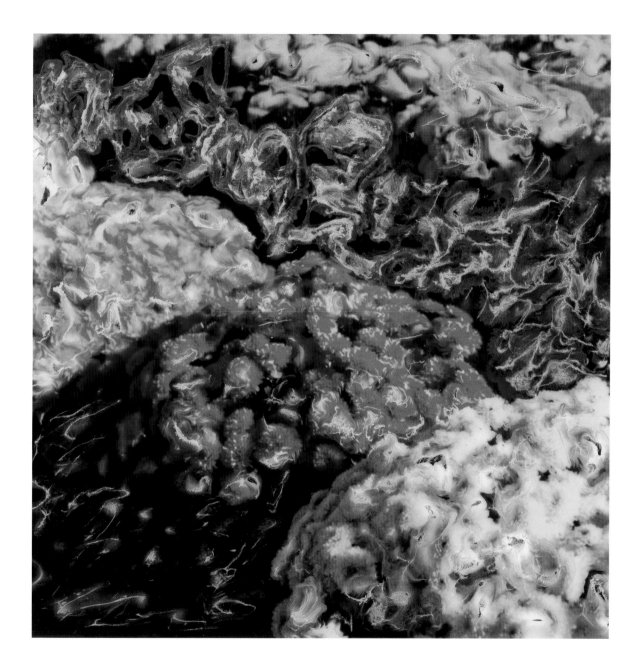

Gold Leaf

In a small
gold leaf

turning dark
at the ribs

as it lies
on the ground,

face up to
a sky grown

colder & dark,
do we see

glory that
has faded

or life
to come

from the earth
it becomes?

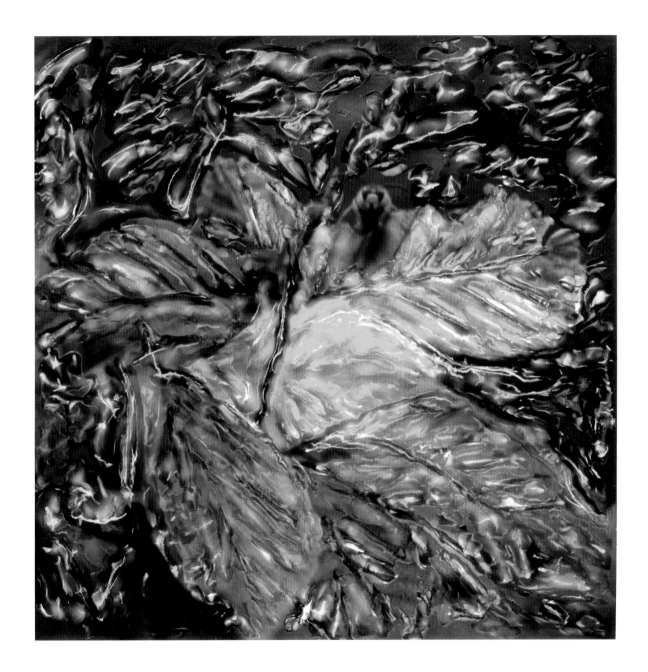

Red Berries

Red berries
birds must love

hang from
slender stalks

& a leaf left
here & there

against a blue
sky shimmers

with curlicues
of light.

All at once
beads of red

set sail & bob
forever on a sea

of whitecap
blue waves.

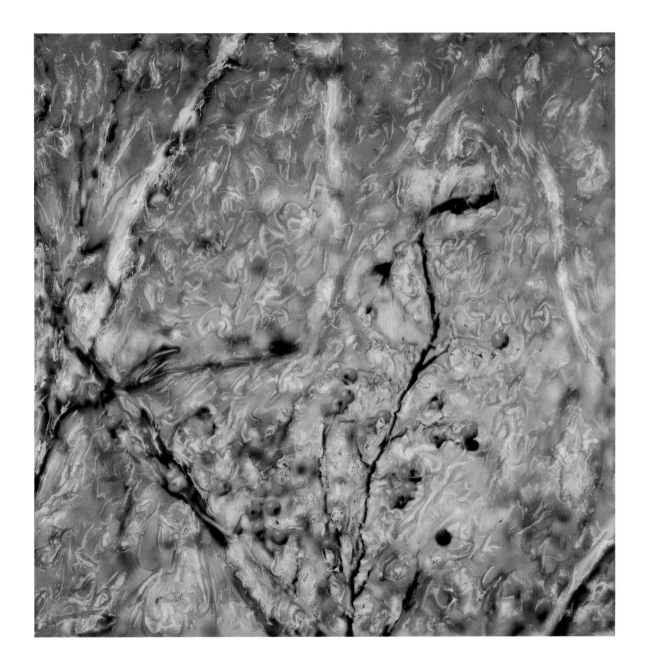

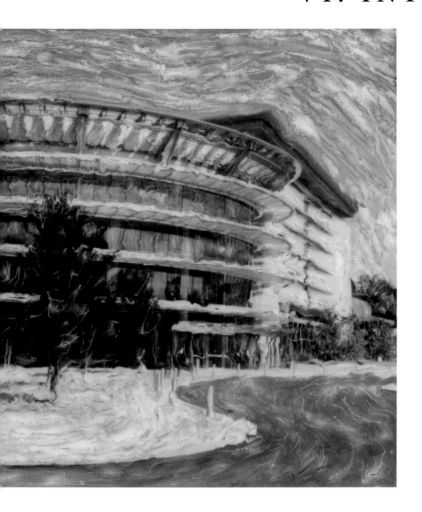

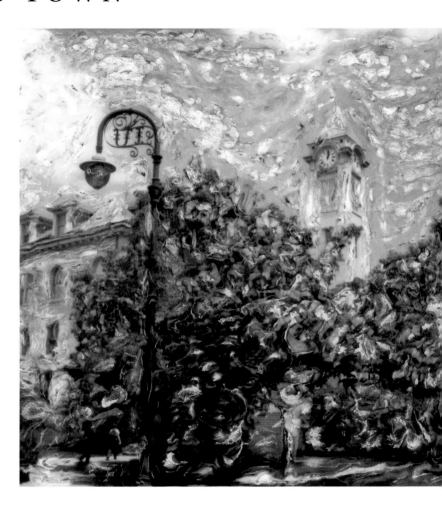

Old Brick House

Light hits an old brick house
in a river town in a way

that burns diagonal stripes
of shade across the shutters

as white curtains gather to form
a dark opening to which spirits

still living inside come to
gawk at us, as we stare in.

Left in a House

So many dreams
sleep in a house,
so many sorrows,
so many joys
behind the curtains.

So many shadows,
so many rays of light
inside the windows.

Sounds of conflict,
sounds of reconciliation,
cries of pleasure,
cries of pain
beyond the doors.

So many memories,
unfulfilled yearnings,
secrets shared & kept,
promises made & broken
behind the picket fence.

So much left unsaid,
so much to say
about what's left
behind in a house.

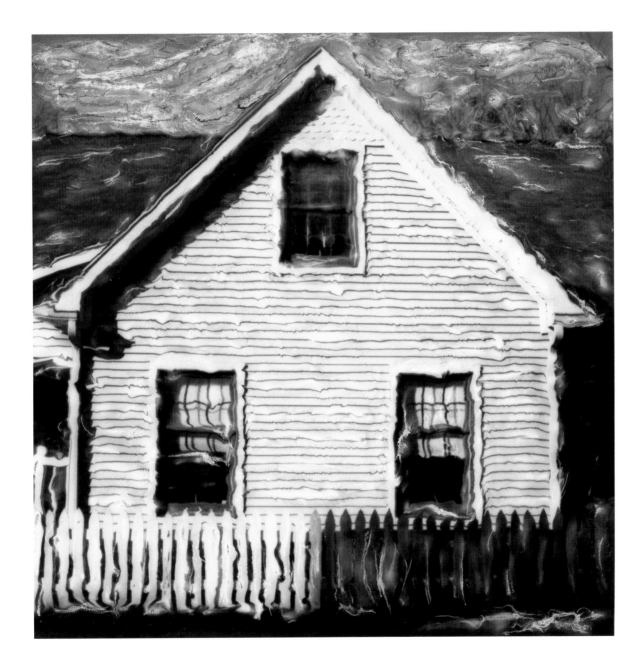

Mystery

Only the dark blue sky
speaks to us in this place
where nobody's home,

but the language it speaks
withholds the story it tells.

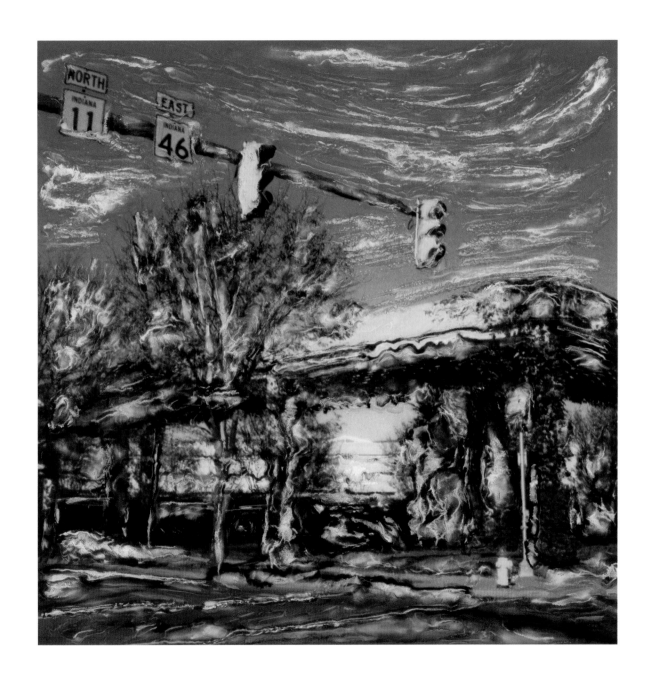

What If Fish?

What if fish flew
in a blue sky over
the house & birds
flipped out of water?

What if shadows
instead of family sounds
leaked out of a house?

What if an animal
lounged in a chair
on the porch
while his master
snored at his feet
on the floor?

What if a poet
built gingerbread houses
made out of words
that when you ate
them gave you
the power to create
an Indiana epic

& a photographer
transformed every
image into a painting
that gave you
the capacity to see
spiritual presence
in all things Hoosier?

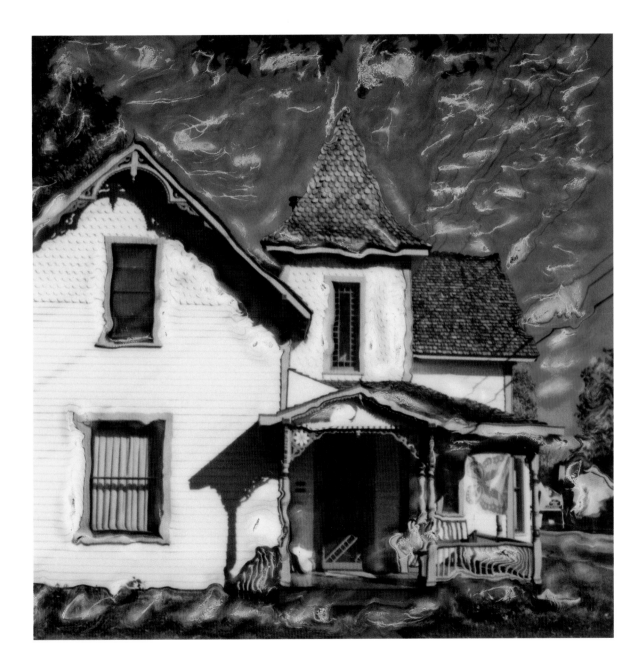

The Footprint

Past the empty birdbath,
beyond the latticed fence

& the arched gate
& the trellis above

where vines twine,
but somewhere before

that spot where leaves
spindle russet & ochre,

above a stand of weeds
that has dried to silver,

is a footprint in a creek bed
that has turned to dry sand,

of someone I remember
but have not seen for so long

I do not know if I could
say her name in the right way

or describe the melody
that lived in her voice.

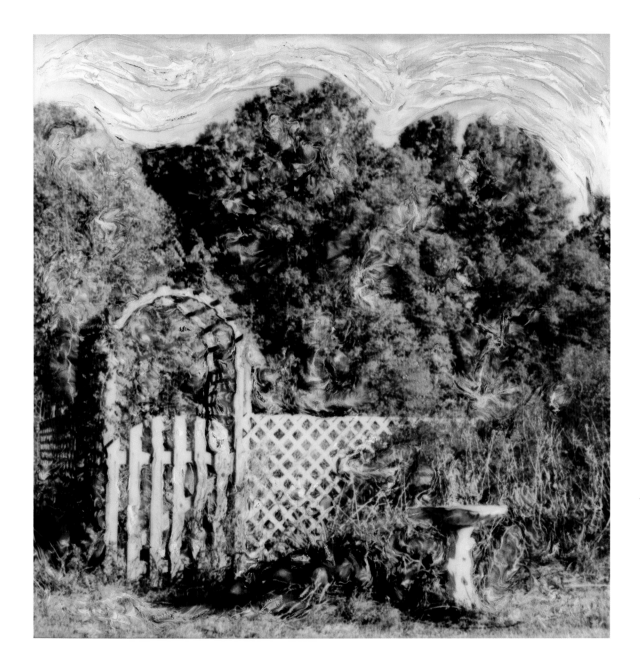

What Would You Say?

What would you say
if I left you a note
on the fence
to come on in
through the gate?

Would you know
where to hang your hat
once you stepped from
the porch into the house?

Would you still know
where to sit down
until I got back?

Would you be able
to refrain from
eating the soup
I left in a pot
on the stove?

Would you recognize me
if I came back home
wearing a new soul
& sang a new song?

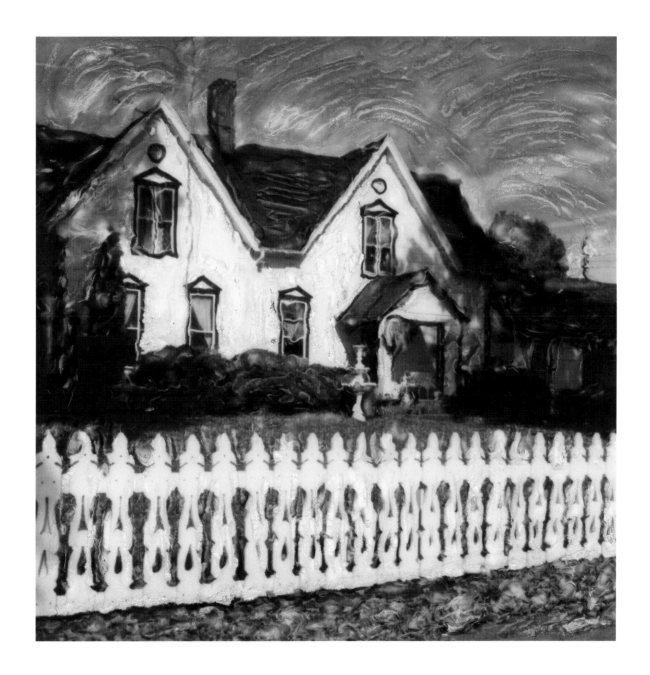

Design for a Deck

I would take a deck with spindled
banisters & make sure the surrounding
trees laid down the right shadows.

Late in the afternoon I would
ice down some beer in a cooler
& place it in the corner & another one

nearby for white wine. My wife would
help me set out, on understated wooden
trays & platters, subtle but delicious dips,

vegetables, cheeses, crackers. I would
turn on the CD player, with the speakers
facing the windows opening onto the deck,

& play the kind of music based in
tradition but which has a contemporary
flavor & speaks for the concerns of all

ages at the same time. As the guests,
all of whom have bought my collections,
arrive, I would compose in my mind

the perfect poem to read at a book party
on a deck, and as our readers raise their beers
or glasses of wine to congratulate us,

I would begin to recite a new poem
about the design for a deck on which
a party is held to celebrate this book.

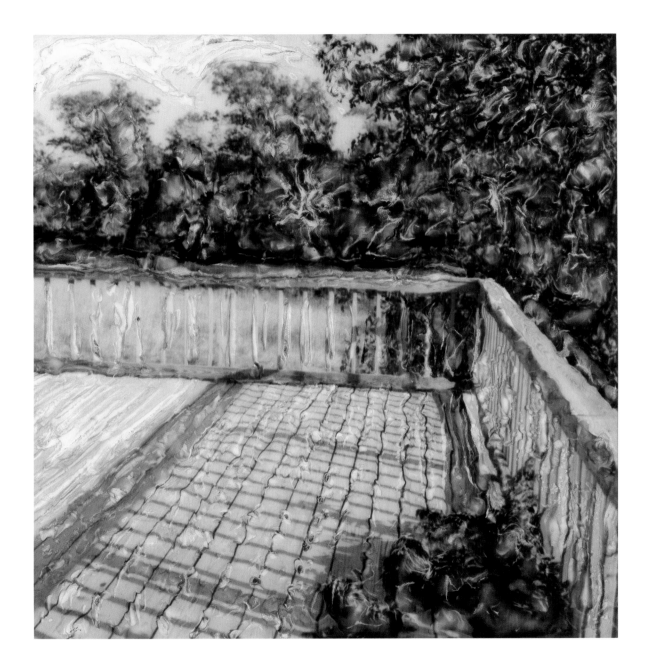

Dog Still Life

If you were a dog
you would be happy
to waddle up these steps
& plop on the landing
& let the sun find
the right angle to lay
its rays on your back
as you look off to the side
musing & meditating
on matters essentially canine.

If someone came around
with a camera you would
not look his way because
you are in your world
& he's in his & he must
come to you if he wants
to capture the essence
of what you see, smell,
& taste & show to others
how sunshine & shadows
discovered you before he
ever came on your scene.

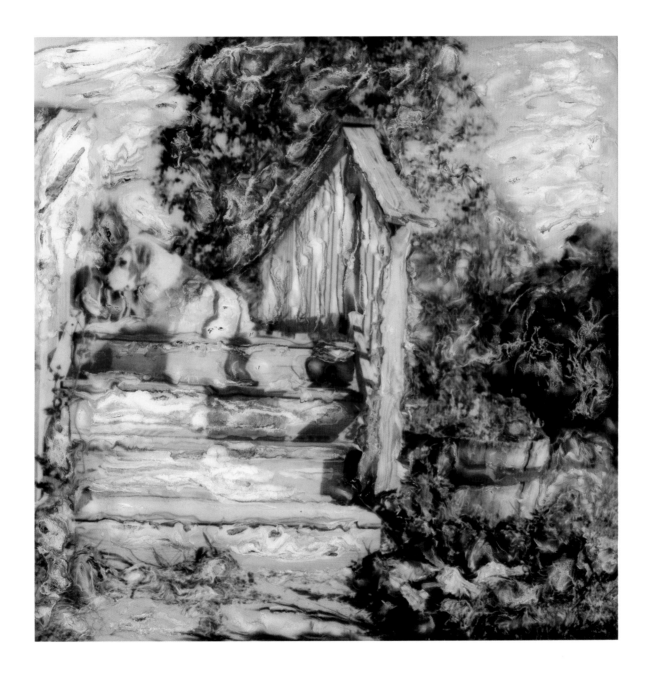

For Whom the Bells

Wherever you were
in my hometown
you always saw

& felt the presence
of that church tower against
blue sky & whenever

the bells tolled everything
stopped, people came
out of their houses

to look together
in the same direction,
& we all wondered

for whom those bells
tolled and gave thanks
that we still breathed.

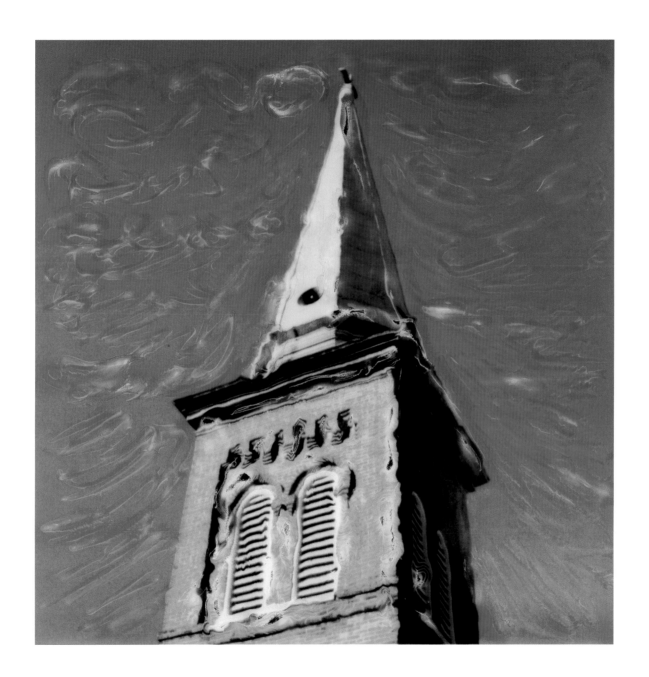

At the Ice Cream Altar

And God said, *On Sundays it is good*
to go to the Ice Cream Altar. Ask the priest

to pull the right handle and be blessed
with your favorite flavor. Push the right

keys & your straw may expand
& resonate like a pipe organ.

Genuflect & bow your head before
the altar on your way out, give thanks,

& be invited to savor this sweet ritual
again when Sunday comes in procession.

Picket Fence

Does the picket fence
along the side

of somebody's house
make me a better

neighbor for not
invading his shadows

or a poorer person
for discouraging me

from entering
into his light?

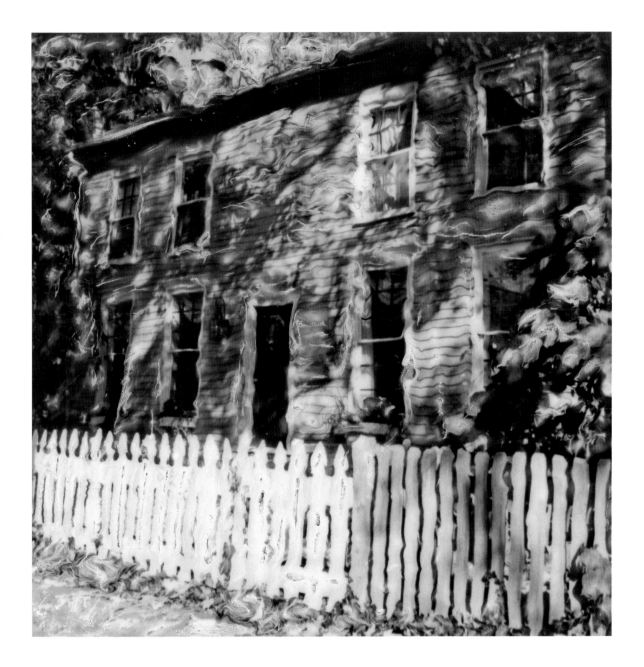

Iron Fence

Sometimes a filigreed
iron fence makes
what's on the other side

seem more attractive
& desirable than what
actually lies beyond.

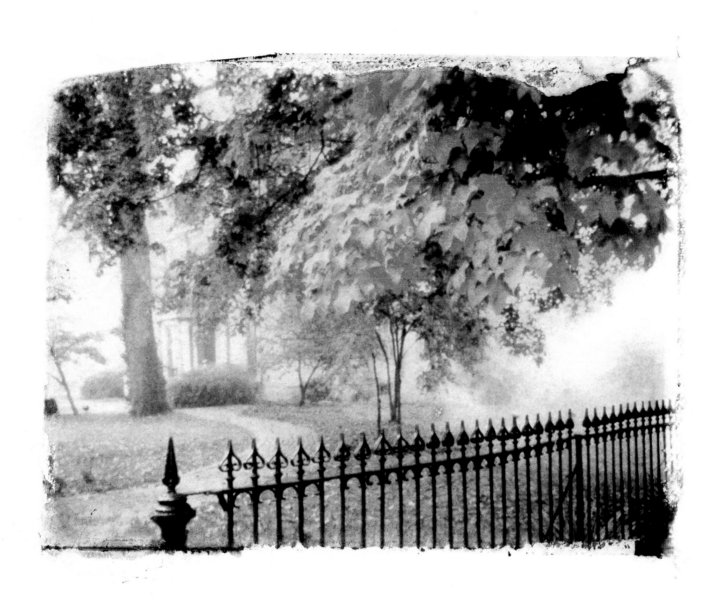

Light

Light on a house
& picket fence

brings shadows
into relief

& qualifies
the boundary

between real
& imagined.

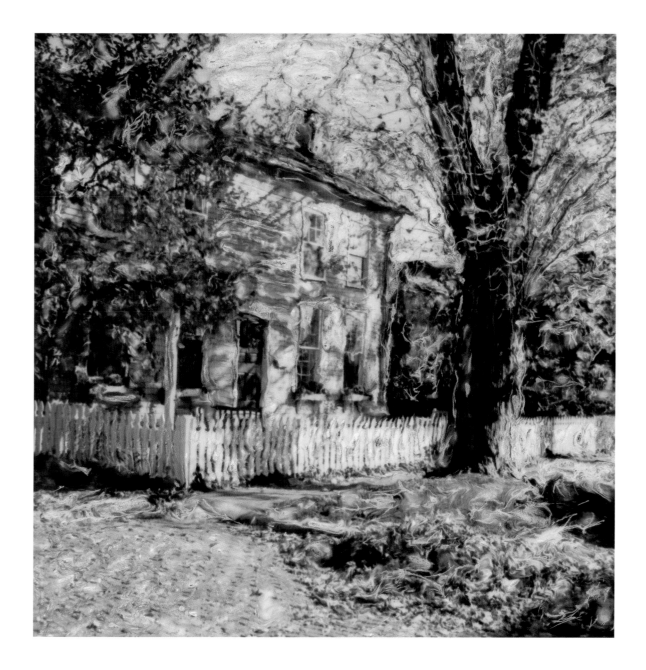

Rest

Sometimes the eye
is relieved to rest

where boards warp
apart & white paint
can no longer lie
tight against clapboards
or the sides of pickets,

the darkening leaves
settle in gutters
as dust collects
in the corners
of the porch,

shadows crawl
on all fours
into spaces & cracks
open to them,

& the broom, pail,
mop, & paint brush
give up the ghost
for the winter.

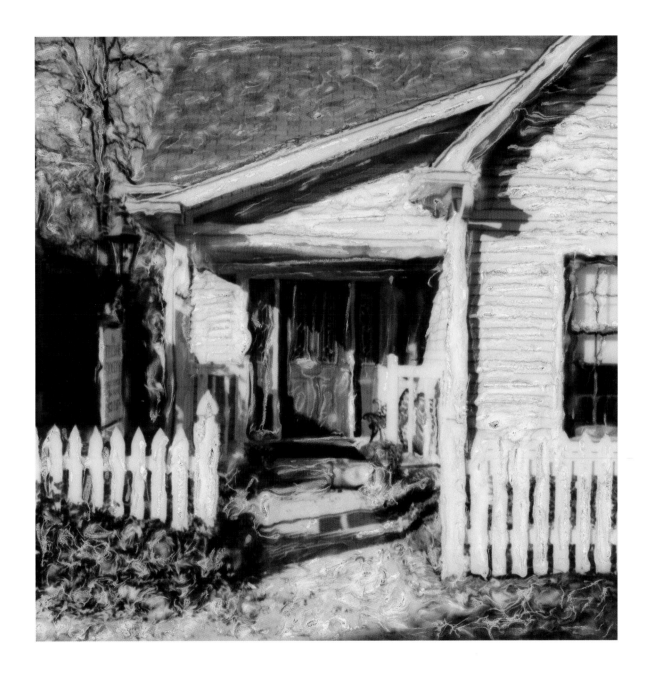

Walking the Streets

Walking small town streets
you can't help but notice
which lights go on
at which time, who raises

his voice two evenings
of three, who stands
under the street light
after it's a little late,

& what time the tavern
door slams shut after
the last regular leaves.
If you also walk early

in the morning, you
see who's driving home
while others go to work,
& in the diner, who needs

a good cup of black coffee
pretty bad. Keep walking
& one day you may meet
a man who looks just like

you; he will ask where you
have been. You will have to
tell him, as gently as you can:
where everybody always goes.

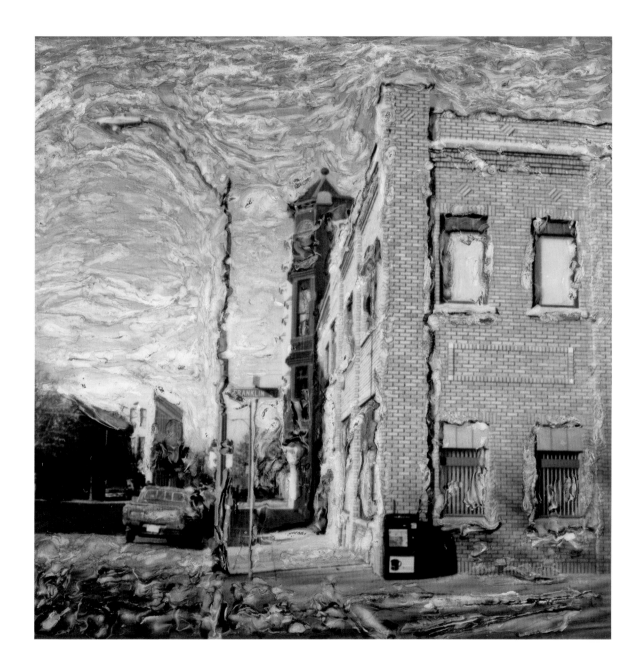

Windows

Walking around town
I sometimes see faces
in the windows of offices

that are closed at night
& hear voices of
people long gone

from these streets,
& if you tell me I
hear what could not

be there, I say
you have not
listened to sounds

that come from beyond
or developed eyes to
see what lives within.

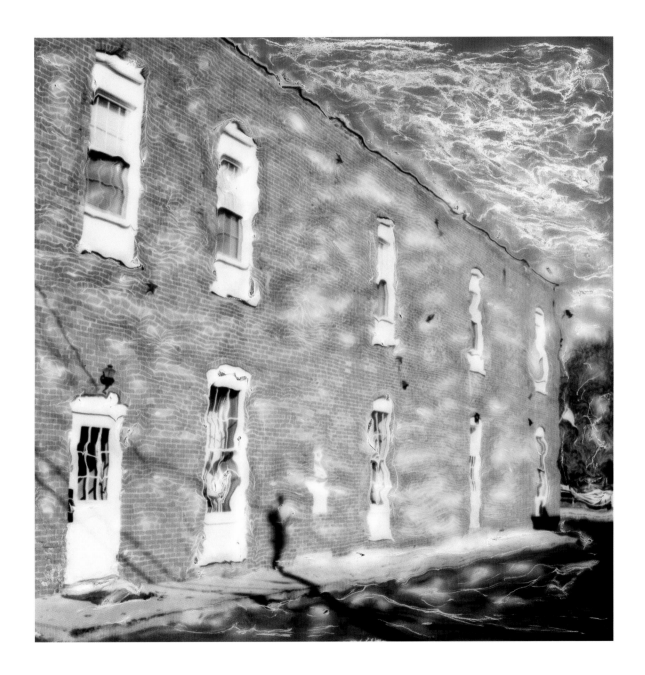

Bouquet of Light

If light makes us see in the night
& running water can make us pure

then whoever turns on the switch
as we step under this bouquet

of bulbs clustered like the heart
of a flower has the power

to shower us in light that
may help us distinguish

shades of good & bad
on the street where we walk

& help us see where we
should put the next step.

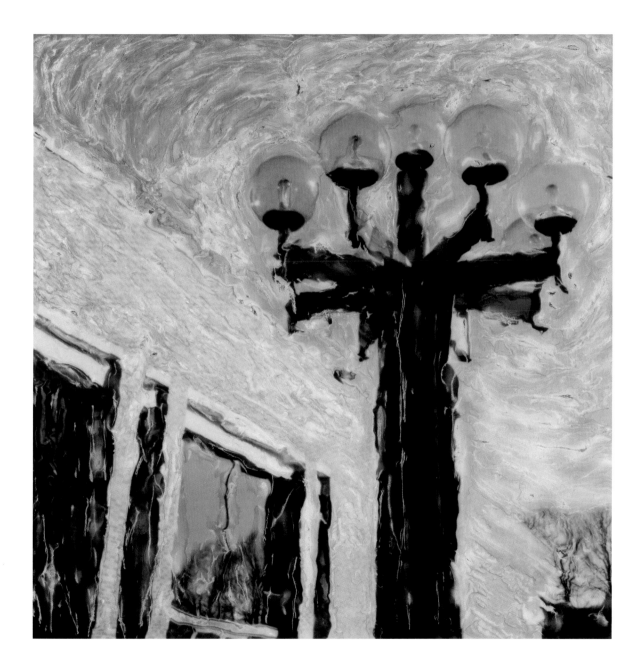

Candles

When we light a candle
let us begin the ceremony
of celebrating the flicker

of light that helps us
perceive & appreciate
the folds of beauty

we must learn
how to open
as we pass through

this world we inherited
& must pass on
to those who follow.

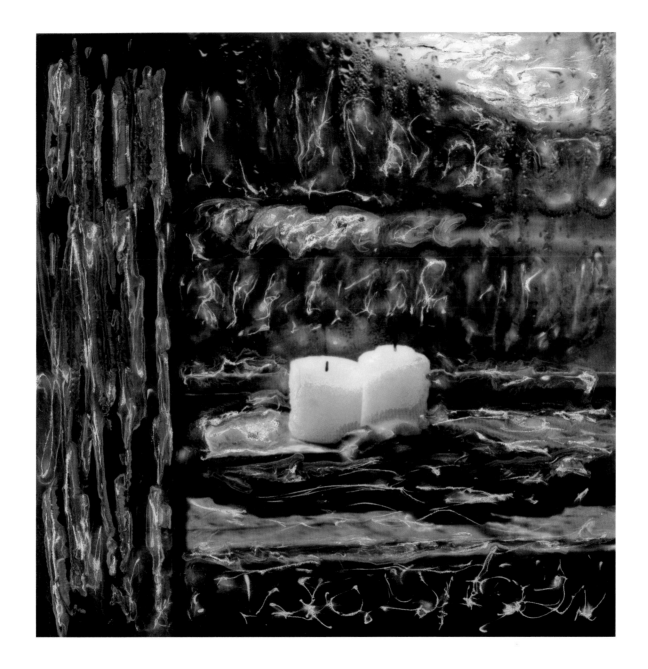

Neighborhood Muse

A pretty girl with soft long hair
that catches the sun as it falls
on her shoulders & across her chest,
a perfectly oval face, rounded forehead,

sensual lips that may want to turn
into a pout, & shadows where her eyes
look back at you, as photographed by her
father, reminds me of Georgia O'Keeffe

when she let her long dark hair fall down
over her shoulders onto her breasts scarcely
concealed behind her partially opened gown
as she looked with sleepy insouciant eyes

at Alfred Stieglitz, training his camera eye
on her. Georgia makes me think of a woman
called Helga lying in bed behind a sheer curtain
as Baltic breezes blew across her sunlit flesh

& Andrew Wyeth picked up his brush
& stroked in subtle colors of restraint
in the right places. Helga makes me think
of Venus whom Botticelli stretched out

on the half shell to our adoring eyes.
These women help us see that the Muse
may come in different guises but always lives
close to the man who keeps his eyes open.

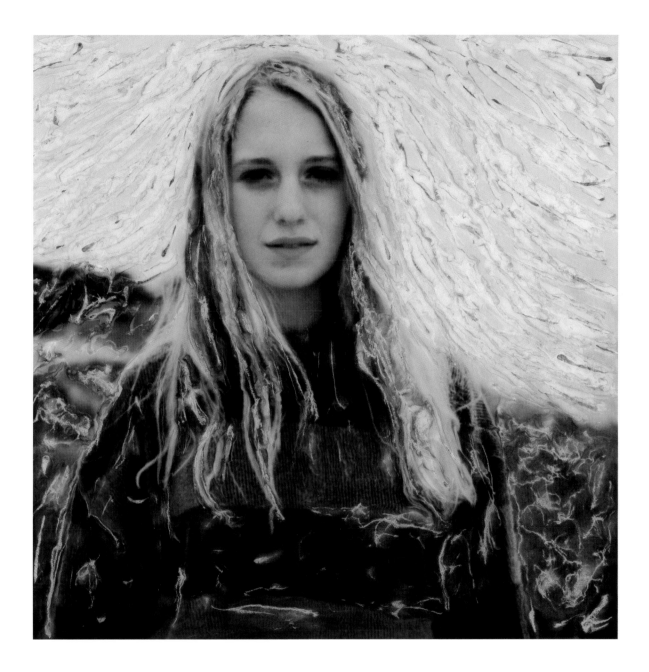

Man in Red Cap

An old man in a red cap
has a million wrinkles
all in the right place

& his lips press shut
& pucker while his dark
eyes bore right into us.

His flannel shirt
features the perfect plaid
& his coat the right squares

as he sits on a bench
with his legs crossed
to show a single boot

in front of all manner
of firewood & junk
piled high at all angles.

All of this convinces us
to vote for him as mayor
come the next election.

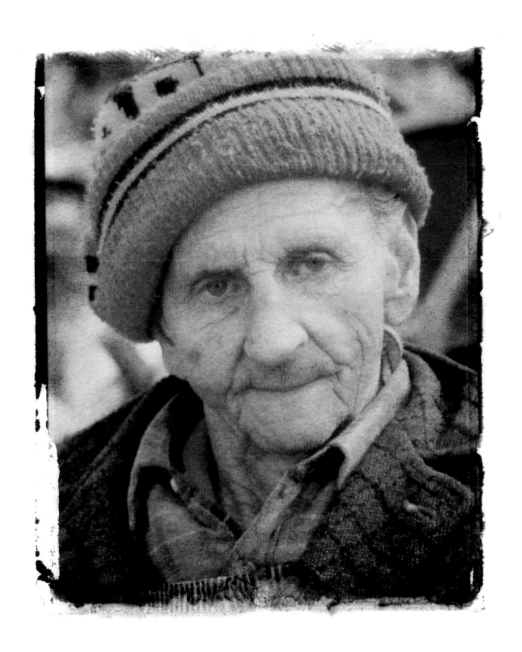

The County Fair Queen Speaks

What do you mean I should
get back down to the ground?

Didn't I flap & flutter up here
all by myself, atop the highest

pole on the whole fairgrounds?
Perched here on my throne,

I can survey my territory below.
I can wiggle my white tail,

flap my fluffy wings, strut
my stuff, cluck about as loud

as a cocky rooster crows,
turn in all four directions

as breezes riffle my under-feathers,
& drop golden eggs like manna

to selected subjects as they
cheer in the ranks below &

cry out my name, without shame,
begging favors from their queen.

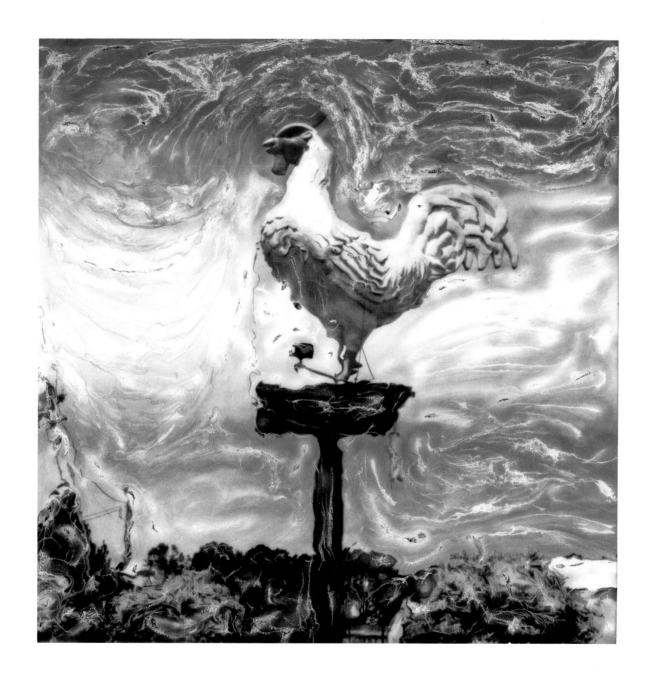

Viaduct

Under the viaduct
shadows congregate,

teenagers gather
to smoke what burns,

pigeons leave white
splatter on the ground,

& as tires hum above,
a tossed kitten cries

for a mother
nowhere in sight.

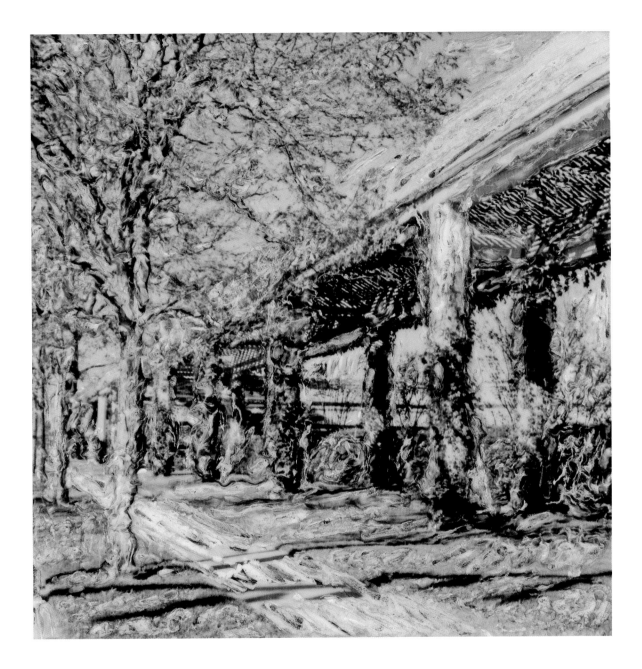

INTO TOWN • PAGE 231

I Buy Red

I'll buy a new one
hot flaming red
& the sun will lay
white streaks that bounce
off the hood & make
you cover your eyes
with your hands.

My driver is one hell-
aceous young woman
who knows how
to hug oval, roar
down the stretch,
put on the wreath,
lay on the smile,
& sip fresh milk.

The press shoots us
arms-on-shoulders,
people name alleys,
mixed drinks, &
a circular freeway
after little old me.

The Chamber of Commerce
gives tours of the old
neighborhood, & the mom
& pop grocery store
where I was bag boy
is the final stop.

I make up increasingly
sarcastic lists of ten
reasons why the Prez
could elevate his
tough-guy game
& win over the pundits
by reading my
books of poems.

Kroger can't keep
enough copies of
my latest collection
stacked at the checkout
& unsolicited contracts
for unwritten books
jam my mailbox
like big fat bills,

but one drawback
is that my silly grin
grows wider & wider
& periodontists write
me come-on letters
as my fame increases.

On every corner
of every street
somebody wants
to shine my shoes

& curvaceous models
emerge out of cornfields
& merge into red-faced
me every time a camera
gropes its way to an eye.

Field Sculpture

An empty semitrailer
stands jacked up by itself
in a rust-colored field
of broom sedge & milkweeds.

How many drivers pulled
how many loads of what kind
of cargo down how many roads
before it was left here to rust
like an old sculpture amid
broom sedge & dry milkweed?

How many pot shots have teenage
boys taken at it with air rifles?
How many lovers have tried
to crawl inside? How many
homeless from our cities would
love to make its empty space home?

How many roads must a semitrailer
travel down, how long must it rust
between broom sedge & milkweed,
before anyone can call it a home?

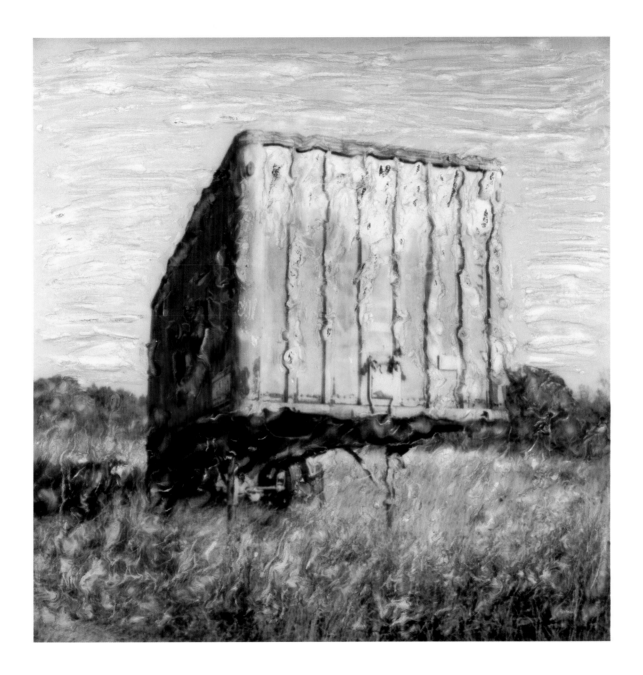

The Court House Bench

The old men with rumpled hats & canes
sat on a bench in front of the court house
talking about whether there were many
squirrels this year, who grew the biggest

tomatoes in town, and who would win
the World Series. They looked out
at us teenage boys cruising in souped-up
cars around the court house square,

guffawed, & dismissed us as mere "squirts"
when our glass-packs rattled & roared.
After our father died at 75 & we buried him
on the side of a hill, my brother asked

if I remembered "those old guys who used
to sit on the bench at the court house."
Yep, I sure did. "Well, that's what
he became," he said, "one of the village

elders." So now that I'm into my 60s
and climbing, I look for my seat on the bench
& wait for tomato, squirrel, and baseball
wisdom to descend upon me in tongues

of fire so that I can proclaim
with a vengeance who all the winners
& losers are and will be & how what
used to be is always better than what is.

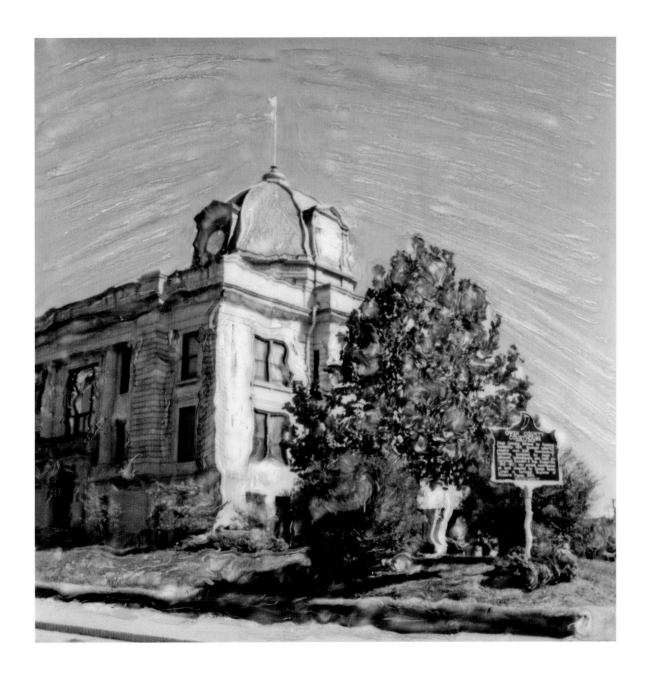

Hoosier Poetry Reading

Look up, from below, and you may see
the legs of a girl dangling from her perch
on a branch near the trunk of a sugar maple
in front of an old farmhouse in southern Indiana.

The girl has finished her chores, but knows
that her bossy big sister will do anything
to get her in trouble, if only she can prove
a theft of daylight time wasted on reading.

Look around and you'll see big sis cruising
the yard, the garden, and the barnyard to catch
the frivolous culprit in the act. Every time
the angry detective passes under the sugar maple,

little sis swallows a giggle over how clever she is
to be reading the dialect poems of Hoosier poet
James Whitcomb Riley in her bower of leaves,
where sparrows usually cheep in chorus.

Let us allow Dorothy, my mother, the girl
reading Riley in the tree, and Frieda, my second
mother, to work out an ending to this 1920s
vignette that nobody had to invent.

When we read our next poem, let us
remember this tale of a girl wise enough
to climb to a higher level to read
her favorite poems in sanctuary.

VII. ALONG THE WATER

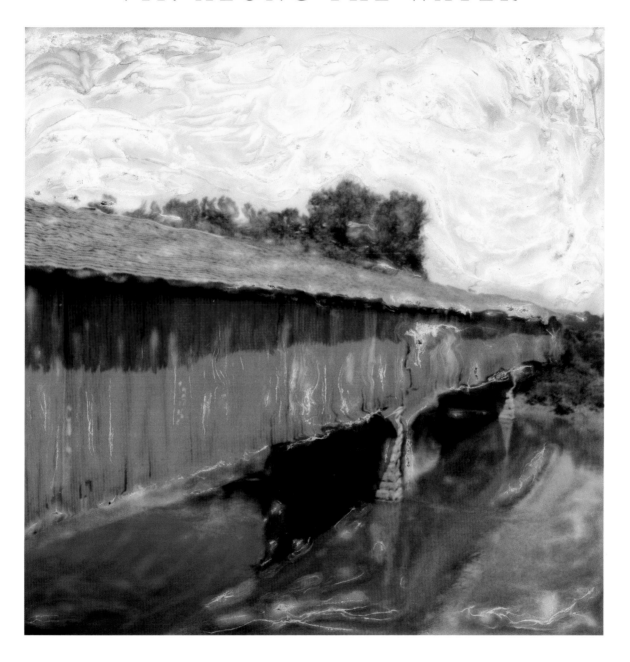

Steamboat

When the Delta Queen
churns on the Ohio,

time flows in either
direction, the bunting

is red, white, & blue,
& you never know

what age you'll step into
when you walk off the plank.

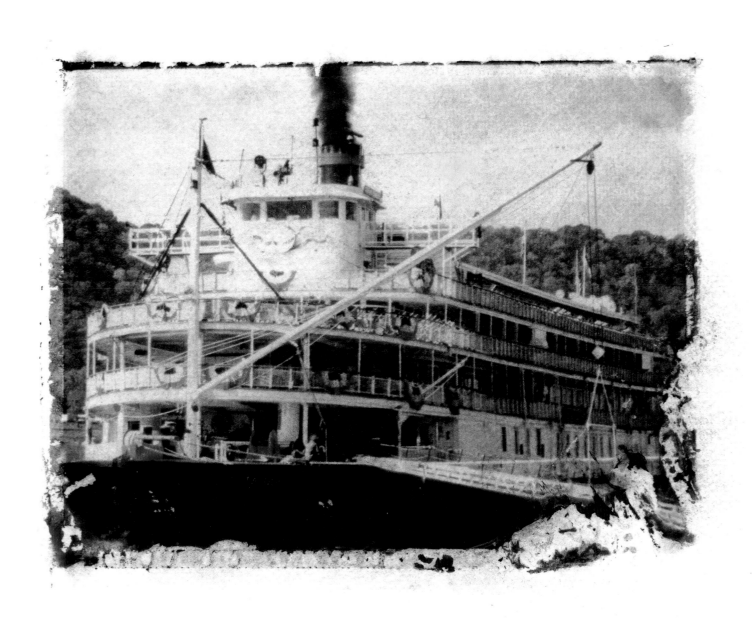

Dock Test

Which is the real dock,
the one above the water
or the one in the water?

Where does wood stop
and reflection begin?

When does sunshine stop
& shadow start?

How many docks
can your eye take in?

On which dock will
you stand before

you take the plunge
into the deep waters?

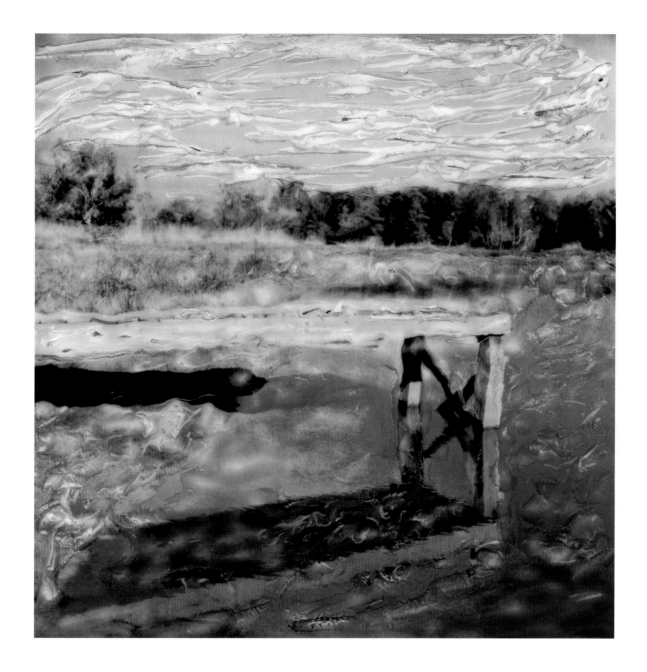

Boy, Dogs, River

Where the river
bent around the back
of my favorite woods

I came with
our bird dogs
Queenie & Ike

to brush against weeds
& smell the water.
The sycamores

& silver maples
made an avenue
that curved where

we meandered.
As we frisked
& frolicked, the sky

was high, the water
was deep, & sometimes
mud sucked at our

boots & paws,
but we were lifted
by all that

curved into our
noses & reposed
in our eyes.

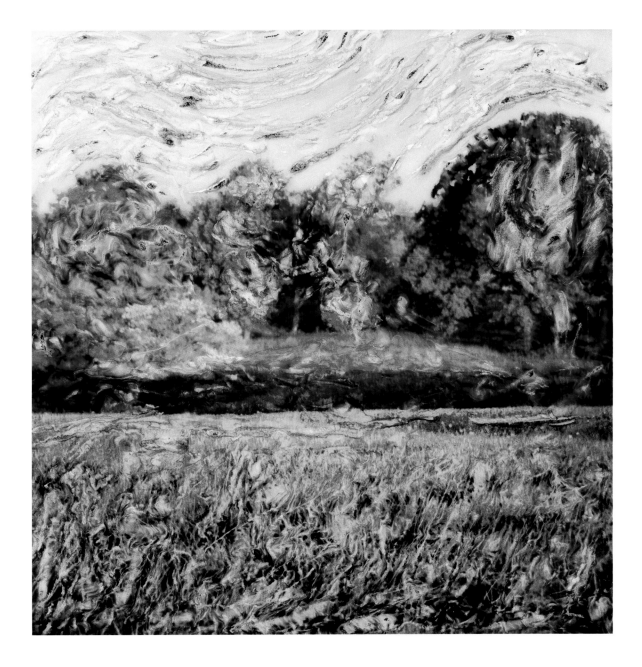

Fish-Story Competition

Take a pond with dark-blue water
& russet-colored sedge growing
around it. Put some bluegills

& crappie in that water. Add a boy
& a girl sitting on the bank holding
cane poles with bobbers they want

to drop into the water. Be nice
& put the worms on their hooks.
Now let the dark breezes blow

as they sit there and dream.
Watch that bobber go under
& the girl pull out of the pond

a fish that flops on the ground.
Let the chivalrous boy remove
the bluegill from the hook

& put it on a stringer he drops
into the water. As dusk settles
on this scene, you finish the story.

Whoever sends in the best ending
gets eternal fishing rights to a pond
with dark-blue water & russet . . .

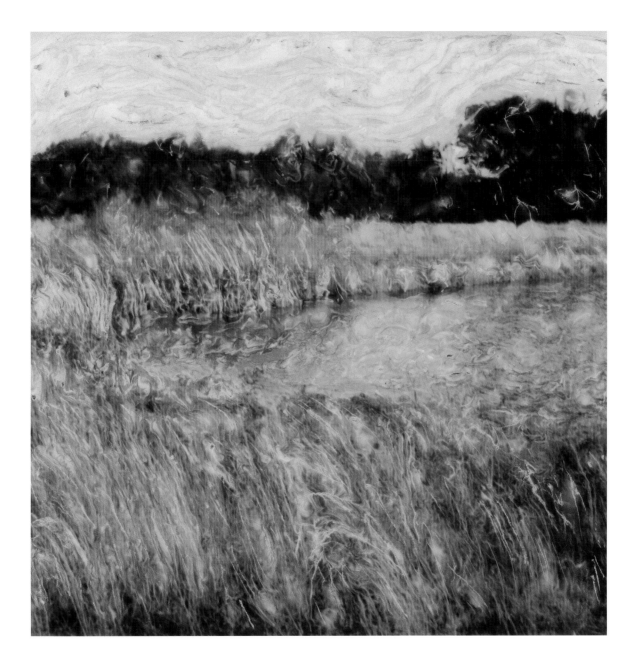

Reflections

Where water deepens
a barn glides
on the surface,

nearby floats a line
of trees & other
farm buildings,

& when you look
up the hill
you see

a barn appear
at the top
& a line of trees,

& the hillside
in the water
is on the verge

of touching the hillside
just above it
beyond the shore.

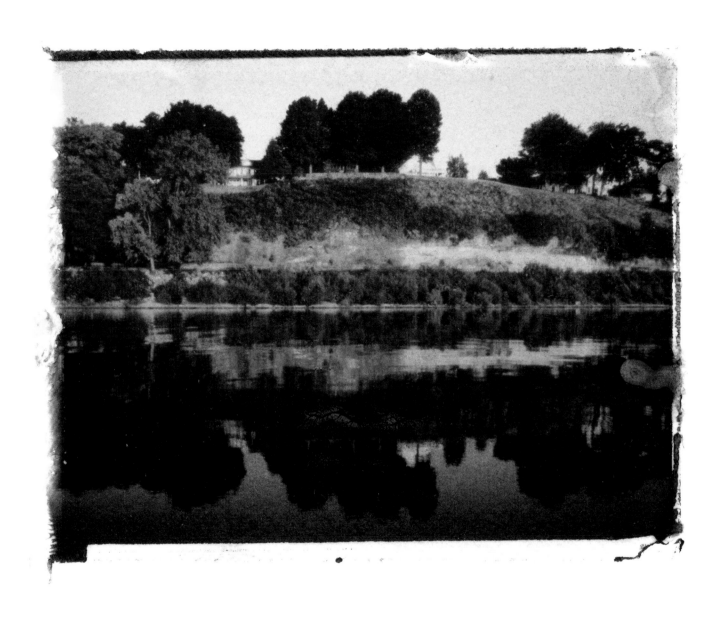

Red Light on Water

Red light
on still water,
streaks of yellow,

a far blur
of trees
on the shore,

& red
in the sky,
darkening,

recall a place
where things
once intensified,

but the where, when,
what, & why don't
splash to the surface.

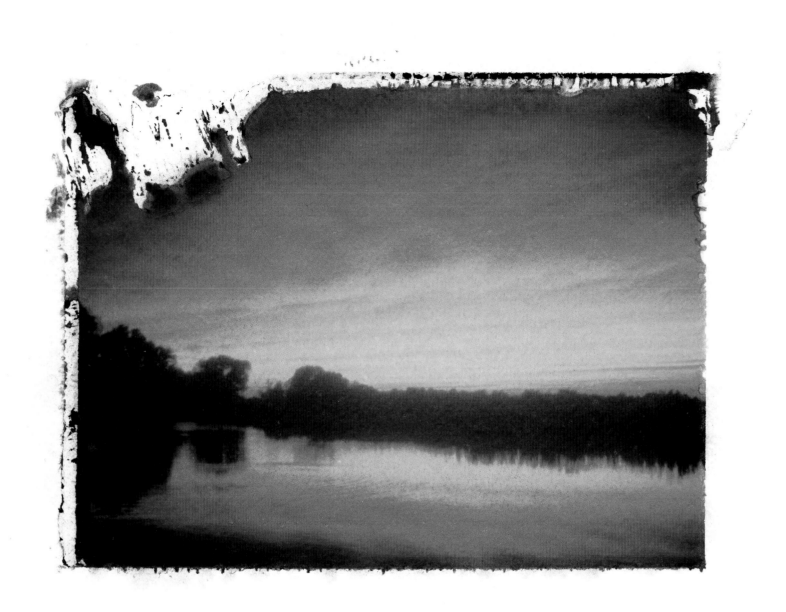

Pond Song

Come with me
& sit on the dock.

Let's dangle our feet
in the warm water.

Dark green cattails
enclose us in privacy.

Somebody's escaped bobber
drifts along by the shore.

The biggest fish flops
way out in the middle,

bullfrogs are ready
to lay down the bass,

& as blackbirds float
a high reedy song

our lips move together
like twin whole notes.

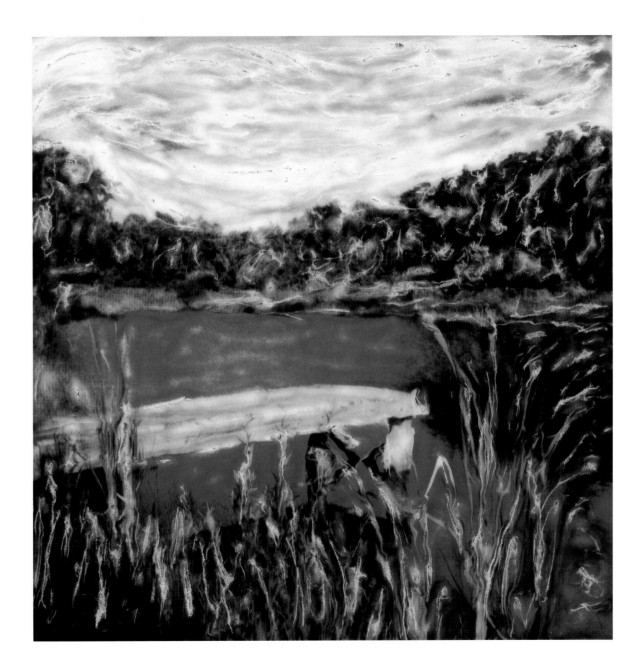

Moonlit Dock

Moonlight settles
on the rough boards

& the smooth water;
the repeated cry

of a bird opens
a path of notes

into a world
way beyond.

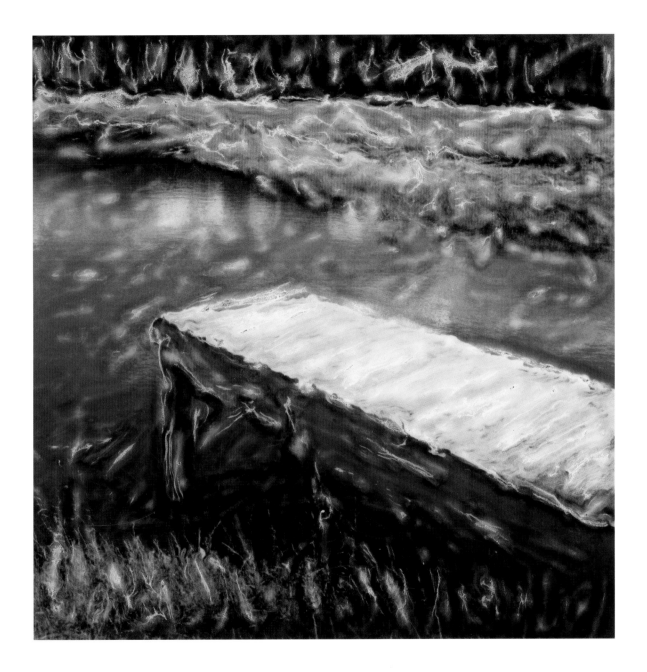

In Sky, in Water

White in the sky,
white in the water,

dark in the trees,
dark in the water,

blue in the sky,
blue in the water:

sun's going down
in the sky, in the water;

into which depths we'll go,
we do not, cannot know.

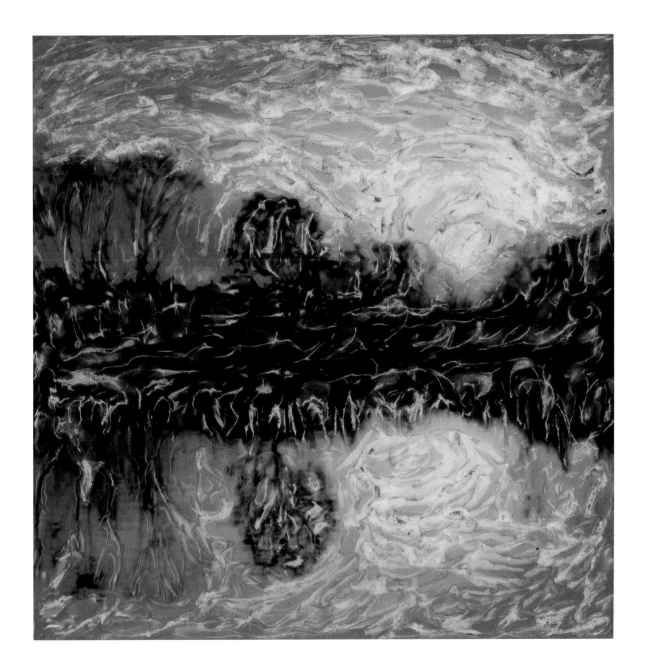

Song of the Red Covered Bridge

Beneath the red covered bridge
the flotsam & jetsam of
ice patches, branches, logs.

How many carriages & cars
have rumbled across the planks
supported by beams on piles?

How much water has flowed
beneath this red covered bridge?
How much more is left to stream?

How long before the maniac among us
scrapes a match across rough surface
& flames leap at every angle

as we begin to compose another
hymn of praise to what we love
about what we once had?

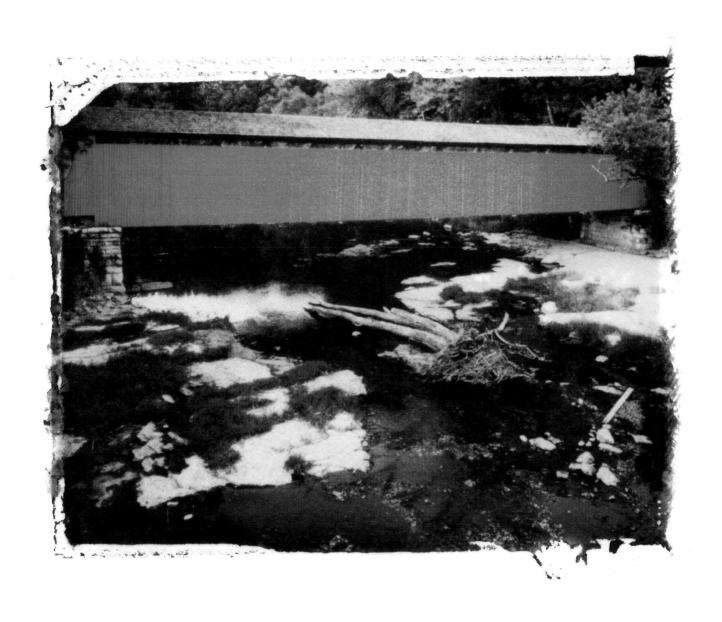

Waterfall

Where the water
flows & falls
over the hill

a white pool
waits to collect
the essence

of what
has been
distilled

& releases
spirit back
into the air.

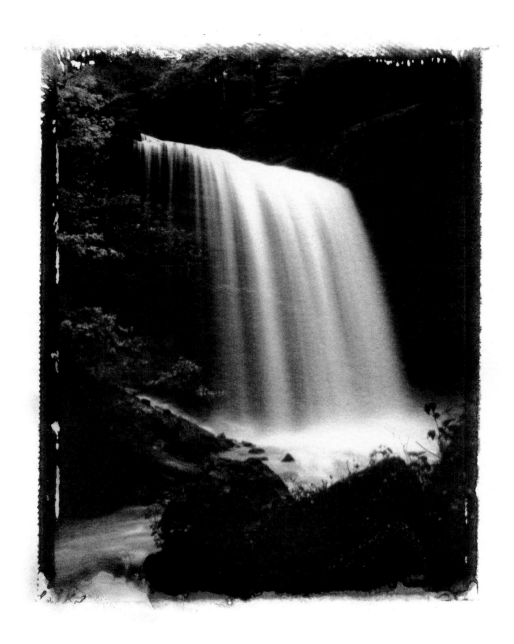

APPENDIX

The Photographs

INDEX: FIRST LINES

DARRYL D. JONES is an accomplished Indiana photographer and author of other Indiana University Press books, including *Indianapolis; Spirit of the Place;* and *Amish Life.*

NORBERT KRAPF, who grew up in Jasper, has returned to live in Indiana after 34 years at Long Island University. Emeritus professor of English, he serves as the first Poet Laureate of the C.W. Post Campus, LIU. His collection of Indiana poems, *The Country I Come From,* a Pulitzer Prize nominee, was followed by *Looking for God's Country.* For further information, see www.krapfpoetry.com.